IMAGES
of America

EAGLE

On the Cover: The Valley Market, situated next to the Eagle Drug Store, was owned by a Mr. Farley. Ruth Ostroot, his daughter, worked in the store along with Chet Edwards. For 20 years, the post office was located in the east end of the market and operated by postmaster Ralph Fluharty and Helen House. (Courtesy EHM.)

IMAGES
of America
EAGLE

City of Eagle

Copyright © 2012 by the City of Eagle
ISBN 978-0-7385-9537-5

Published by Arcadia Publishing
Charleston, South Carolina

Printed in the United States of America

Library of Congress Control Number: 2011942506

For all general information, please contact Arcadia Publishing:
Telephone 843-853-2070
Fax 843-853-0044
E-mail sales@arcadiapublishing.com
For customer service and orders:
Toll-Free 1-888-313-2665

Visit us on the Internet at www.arcadiapublishing.com

This pictorial history of Eagle is dedicated to the late Weldon Fisher, a descendant of the pioneering Fisher family and an unwavering supporter of the Eagle Historical Museum.

Contents

Acknowledgments		6
Introduction		7
1.	Eagle Island Beginnings	9
2.	Townships and Transportation on the North Shore	21
3.	Arid Land Watered by Ditches	35
4.	Processing an Abundant Harvest	51
5.	From Blacksmithing to Industry	65
6.	Uplift 10 Miles from Boise	75
7.	Business in Orville Jackson's Tall Shadow	95
8.	In Pursuit of Leisure	109

Acknowledgments

The author wishes to thank three Eagle residents in particular who made multiple and continuous contributions to this book project: Phil Fry, Lois Kunkler, and Ron Marshall. Our thanks also goes to the following for donations of images and for valuable information on Eagle's past: Edith Cohen, Larry Crist, Les Cullen, Myrna Ferguson, Leona Judson, Beverly Merrill, Vicki Nielson, Paul Quong, Ann Rogers, Shari Sharp, Tim Soran, and Larry Walker. Eagle Historical Museum volunteers Pam Kelch and Alana Dunn provided valuable research assistance for this project. Eagle city clerk Sharon Bergmann, who oversees the Eagle Historical Museum, provided advice and encouragement. The author takes sole responsibility for the historical interpretations and opinions expressed in this book.

All photographs attributed to EHM are from the Eagle Historical Museum's historical photograph collection.

INTRODUCTION

Today's city of Eagle, Idaho, is both geographically and demographically something of a phenomenon. It cuts a wide, 9.3-square-mile swath across the middle of the Boise River Valley, embracing extensive foothills, fertile bench lands, a picturesque flood plain, and a 2,400-acre island between two river channels. This great variety of terrain and its proximity to water partially explain Eagle's attraction to wealthy and successful migrants for the past several decades. For Eagle now has, by far, the wealthiest and best educated population of any community in Idaho's only true metropolitan area—the so-called "Treasure Valley." This new Eagle, with its disproportionately large financial and political clout within the region and the state, seems to have full-blown sprung up from farmland and sagebrush. In reality, Eagle has had the advantage of a rural community history that gave it a foundation for planned and cooperative development once Idaho began to experience the late-20th-century population growth of the interior and naturally arid West.

On the face of it, Eagle would seem to have a fairly shallow history. Can any other city documented by the Arcadia Publishing in its Images of America series claim an incorporation date as recent as 1971? Incorporation, however, was a late development in the chronology of the Eagle community, a history almost as lengthy as the civilian settlement of Idaho itself. There are actually three dates that could make a legitimate claim to begin Eagle's story: 1863, 1895, and 1904.

During the latter half of 1863, four 20-something ex-miners built a primitive cabin on a large island in the middle of the Boise River, a dozen miles downstream from the US Army's then new Fort Boise. Intending to supply food to the fort, the newly platted Boise City, and Boise Basin gold-mining region, the men named the island Illinois after the home state of their leader, Truman C. Catlin. This island would soon be renamed Eagle by Catlin for all the bald eagles nesting there. Successful irrigated agriculture and stock-raising pioneered in the Boise River Valley on this island, making Catlin and his family wealthy by the early years of the 20th century.

In 1895, Nova Scotian surveyor and businessman Thomas Aiken moved with his wife, Mary, and their three daughters from a farm on Eagle Island to a newly acquired property on the mainland to the north. This initiated settlement in what would eventually became downtown Eagle under Tom Aiken's aggressive promotion and development. Foremost among Aiken's early accomplishments was getting a county bridge built across the two channels of the Boise River during the spring of 1903, thereby connecting his properties and making his little settlement a north-south crossroad for the mid-Boise River Valley.

During September 1904, a plat was filed with surrounding Ada County by the local Odd Fellows lodge for the township of Eagle. The new township combined Aiken's property with that of the legendary stage driver John Carpenter to the north. The two properties were separated by the old Valley Road, the main east-west artery connecting Boise with Idaho towns to the west and with Oregon. First a city trolley in 1907 and then increasingly the automobile would link the new town to the rest of the Boise River Valley via the Valley Road, soon to be renamed State Street. A town and finally a city would grow from the 1904 plat, slowly for eight decades and

then, beginning in the mid-1980s, explosively. The town of less than 400 residents in 1970 has more than 20,000 today.

As important as key settlement and real estate dates are to establishing a community's history, the development of a physical and institutional infrastructure may be an even more significant indication of solid social advancement. In this regard, Eagle's civic and economic progress prior to its 1971 incorporation is indisputable. An infrastructure had been built in and around the village of Eagle that included public transportation; three local taxing districts for public schools, fire protection, and sewage services; an irrigation system; six churches; a volunteer public library; a large food processing industry; and a thriving, compact business district anchored to druggist Orville Jackson's famous general store.

For most of its history, Eagle was a bustling farm town serving a large, rural hinterland. What mainly follows is the story of this agricultural period in words and pictures. After its 1971 incorporation, Eagle was deliberately transformed into a very different place, in part by its older, landowning families as well as a newly arrived group of business and technical people, retired professionals, investors, and developers. Working farms, croplands, dairies, and food-processing facilities disappeared around the downtown core to be replaced by upscale housing, handsome commercial development, financial institutions, and manicured golf courses. The old workaday downtown was also largely replaced by a village of fashionable boutiques and eateries.

This book does not provide a systematic narrative history of Eagle. That has already been competently done by the dean of Idaho historians, Arthur Hart, in his 2008 title *Life in Eagle, Idaho*. Instead, this book showcases a massive ingathering of newly donated images and local information by the Eagle Historical Museum and tries to provide just enough of a community history to give these materials context and meaning. This collection of images shows a very diverse community, mixing public affairs with domestic, business with pleasure, institutions with families, and the rural community with a modern town. In short, this book is as eclectic and quirky as real local history usually is, with a gloss of organization and validation by two local historians and the experienced editors of Arcadia Publishing.

One

Eagle Island Beginnings

The Eagle area was first settled on Eagle Island in 1863 by Truman Coe Catlin, a young farmer from Illinois. Catlin made a preemption claim for 160 acres and began to raise potatoes and corn for gold miners in the nearby mountains. He soon had beef cattle as well, and it was these that brought him wealth. As he grew older, Catlin shifted to dairy cows, thereby starting a tradition of dairy farming on Eagle Island.

Catlin made early use of the Boise River for irrigation, running shallow laterals from the river's edge to his first crops. Cooperating with his neighbor Polete Mace, he later created a three-foot-wide irrigation ditch that used gravity flow from the higher eastern end of Eagle Island. This was the area's first substantial irrigation effort, followed by many larger mainland ditch projects, to irrigate at higher elevations.

In terms of the community of Eagle, the most significant early island settler was a Canadian surveyor named Thomas Hugh Aiken. During the mid-1870s, Aiken took over the homestead of Henry B. Conway, who owned the stage stop near the junction of Valley and Horseshoe Bend Roads. In 1883, Aiken married Conway's daughter Mary. This couple was instrumental in the founding of Eagle.

Flooding was a constant fear of Eagle Island's settlers and remains a concern of today's wealthy island residents. The Boise River's Arrowrock Dam was completed in 1915 but failed to prevent incidental island flooding during the 1930s. In spring 1943, massive snowmelt sent water over the top of the dam, which eroded Eagle Island soil, flooded the honor farm, and closed the island's bridges. Dikes built along the north shore of the island in 1946 and two more Boise River dams built in the 1950s have not completely eliminated the threat. The flooding in spring 2006 threatened the island's fashionable Island Wood homes; additional dams are now being envisioned by basin planners.

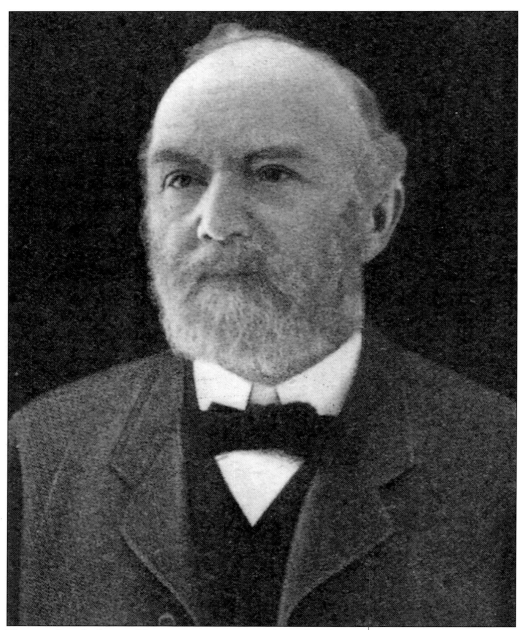

Truman Coe Catlin, an Illinois native, was an early settler who came to Idaho to mine gold but quickly turned to farming. In 1863, Catlin used a preemption claim to acquire 160 acres on what was to become Eagle Island. From his homestead, he operated a cattle business ranging from 1,000 to 3,000 head. Catlin managed his cattle and ranch business for about 45 years and slowly added to his homestead until he had about 600 acres. In 1917, he decided to start a new venture, so he sold 3,500 head of beef and switched to raising dairy cattle. At the time of his death in 1922, the Idaho State Historical Society's annual report duly noted that "Truman Catlin started life in the West with his bare hands, a stout heart, the determination to succeed, and little else." (Courtesy EHM.)

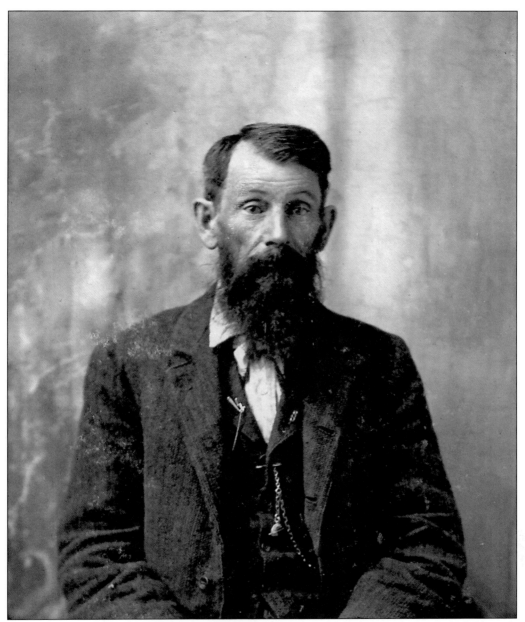

In 1864, Truman Catlin and Polete Mace built the first irrigation ditch in the area. Mace, a French Creole from New Orleans, had also worked as a miner before moving to his own homestead claim on the island. Mace sailed from New Orleans in 1863 for San Francisco and, once in Idaho, joined a pack train for the gold rush to Boise Basin. At the time he and Catlin began homesteading, the island consisted mainly of cottonwood forests and gravel bars, and cattle raising was the principal occupation. Though irrigation projects were in their infancy, the three-foot-wide ditch these two pioneers dug diverted enough water from the Boise River to irrigate 700 acres on the island. This amply demonstrated the value of such endeavors and was the very successful first step in a 40-year effort to bring water and crops to ever-higher elevations. (Courtesy Jerry Mace.)

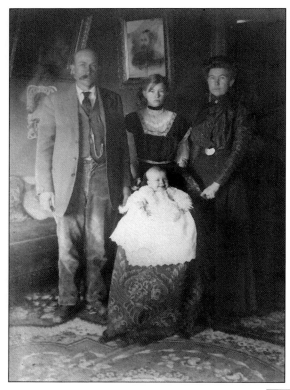

Polete Mace and his wife had eight children, three of whom died in infancy. They were all raised on the island, and all but one remained in Eagle. Charles, the oldest, became a well-known stockman and farmer. Following his marriage to Mary Venable, he purchased 60 calves to begin raising stock on the island and multiplied his investment many times over. He also became a successful businessman and was one of the first incorporators of the First National Bank at Meridian. Charles and Mary had two children: Arita and Leonard. At left, Charles poses with Arita, Mary, and baby Leonard. Below a slightly older Leonard, or "Whitey," as he was known, poses with his dog. (Both, courtesy Jerry Mace.)

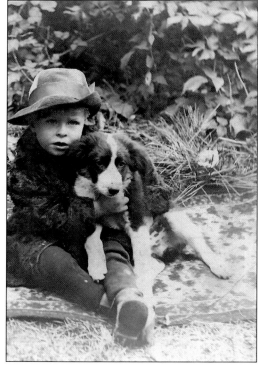

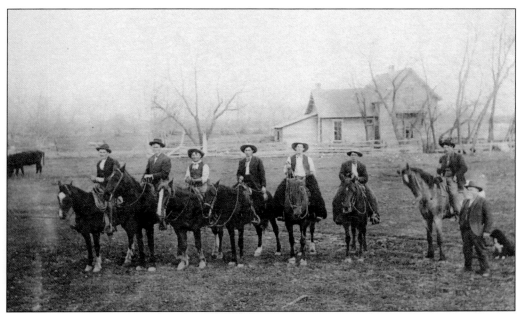

Thomas Aiken (standing above, right) poses for the camera with his ranch hands in front of his Eagle Island homestead, constructed in 1891. Three boys from the Brashears family, Billy Crowder, Wes Mace, Hugh Johnson, and an unidentified man make up the crew. Below, the ladies take center stage. Mary (Conway) Aiken, Aiken's wife, stands in the center of the foreground group and is flanked by two of her adult daughters, Mabel (far left) and Bertha (far right). The homesteading life was far from easy, and in October 1940, Mary recalled the hardships of life on the island. Inclement weather and the need to cook and perform other domestic duties for the farmhands as well as her own immediate family defined her daily existence. (Both, courtesy Gordon Melvin.)

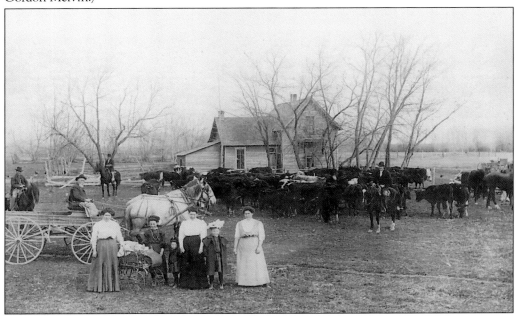

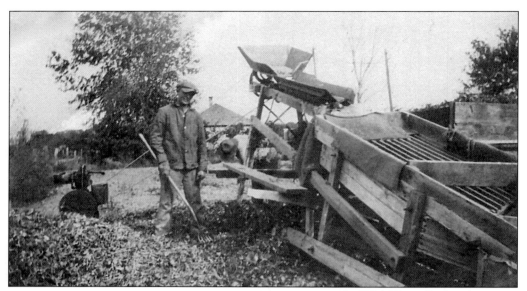

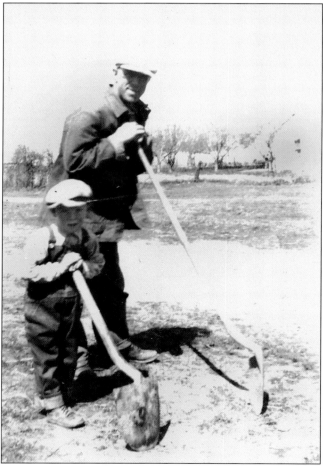

In 1904, Elmer Frederick Kunkler moved with his wife, Chloe, and their four-month old baby to a farm on Eagle Island. The property was located on Artesian Road near the Eagle Fish Hatchery and the Truman Catlin acreage. In this 1929 image above, Kunkler loads onions into a sorter, which was powered by a single-cylinder gas engine that rocked the onion box, separating the onions by size. In addition to growing onions, the family maintained a dairy herd and sold milk and cream. Below, Kunkler and Elmer Jr. take a break from their labors long enough to pose for this picture. (Both, courtesy Lois Kunkler.)

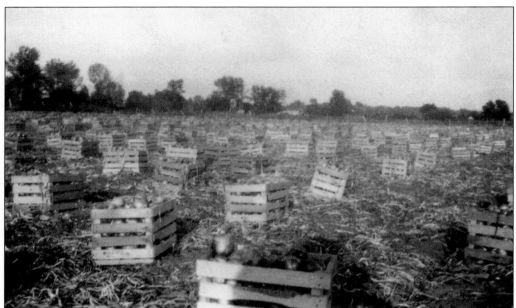

Walter Alvah Rogers and Ruby Opal Cattron were married on November 17, 1920. In 1923, they purchased 20 acres on Eagle Island. Onions and potatoes were the main crops, which the Rogers family sometimes alternated with corn and grain. Alfalfa was also grown to feed their animals, which included 20-some Jersey dairy cows whose milk was sold to the cooperative creamery in Caldwell. Pictured above is one of Walter Rogers's many recently harvested onion crops, and to the right is an unidentified toddler standing next to one of those onion crates while dressed in her Sunday finery. (Both, courtesy Ann Rogers.)

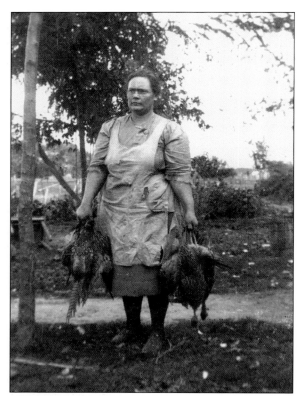

Ruby Rogers has her hands full holding game shot by her son Alvah Rogers. Many island farming families supplemented their diet with local wildlife, and the Rogers family was no different. They also raised a variety of animals for slaughter and shared as needed with their neighbors, who in turn shared with others. (Courtesy Ann Rogers.)

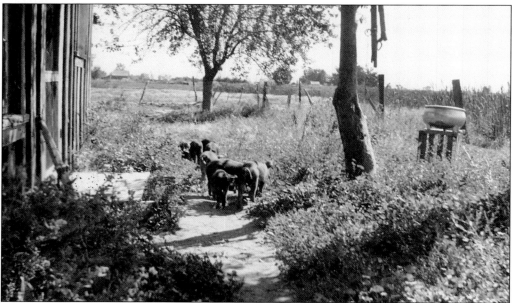

The pigs huddled here were among the many animals that were raised to feed the Rogers family. Farming life often meant subsistence living, and other methods were frequently sought to make ends meet. Walter also kept bees and trained and sold cocker spaniel hunting dogs. His wife, Ruby, raised chickens and sold their eggs. (Courtesy Ann Rogers.)

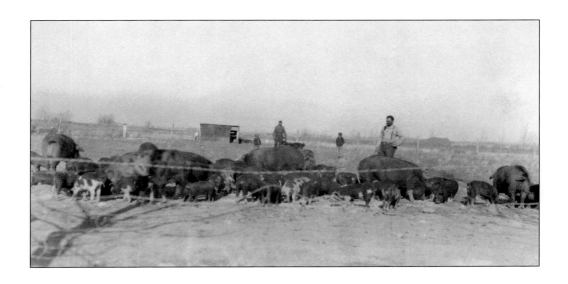

Swiss immigrant Eugene Irminger was also drawn to Eagle Island. One of the most successful farmers in the area, he raised a variety of stock animals but is best remembered as the dairyman who brought Holsteins to the island. His farm, one of the island's larger operations, was located near Linder Road. A lifelong bachelor, he shared his home with the Jacop Spielman family, who helped him farm the land and maintain the household. Above, farmhands deal with a herd of Irminger's pigs, and below, one of the Spielman children wrestles with a recalcitrant gobbler. (Both, courtesy Ann Rogers.)

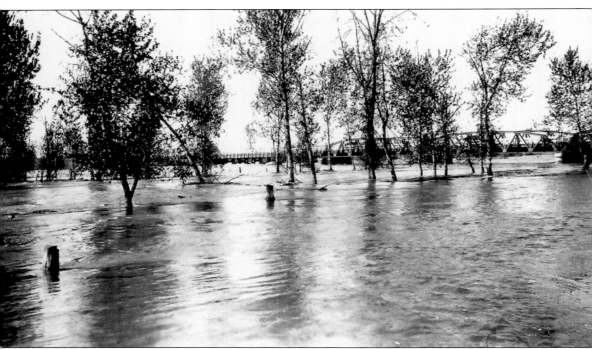

In 1943, the Boise River Valley was the scene of a terrible flood that occurred when Arrowrock Reservoir spilled over its walls and sent water plummeting into the valley and floodplain below. At the time of this flood, protection structures on the Boise River consisted of Arrowrock and the small Diversion Dam, both originally designed for irrigation. Following Arrowrock's construction, valley residents became comfortable with the thought that flooding was no longer an eminent threat, and they began constructing their homes directly in the floodplain, as there was little choice on the island. Former Eagle Island resident Ann Rogers remembers a flooding once in the 1930s and then again in 1943. With the 1943 flood, the river changed its channels, reducing her grandparent's farm by five acres as well as causing widespread damage to other farmers throughout the island. (Courtesy EHM.)

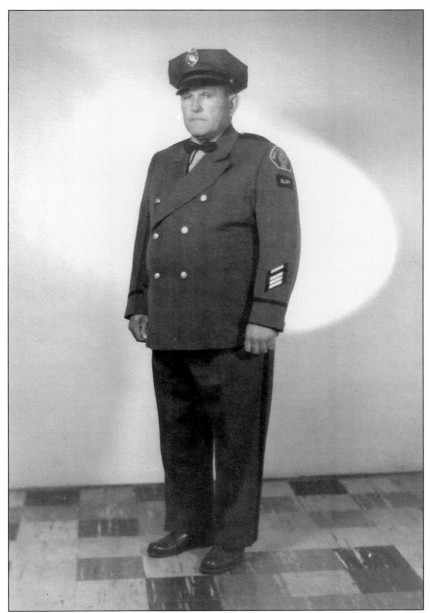

In October 1929, the State of Idaho bought the old Truman Catlin ranch on Eagle Island to convert it to a prison honor farm. Although a large farm where vegetables would be grown for market never materialized, a large and prosperous dairy farm did. Superintendent Harry Roark, who had previously served as farm boss at Mosley Ranch, the prison farm located closer to the main penitentiary, was able to report in January 1950 that supervised trusties had developed one of the highest-producing Holstein herds in Idaho. Land leveling, fertilizer, and a drainage system had converted rough acreage into a farm capable of feeding 100 dairy cattle and 200-to-300 hogs. Because the farm was also able to raise all the crops needed to feed the animals, it was completely self-supporting and supplied the main penitentiary population with all the meat and dairy products it needed. Here, Roark poses in his official superintendent's uniform. (Courtesy Lois Kunkler.)

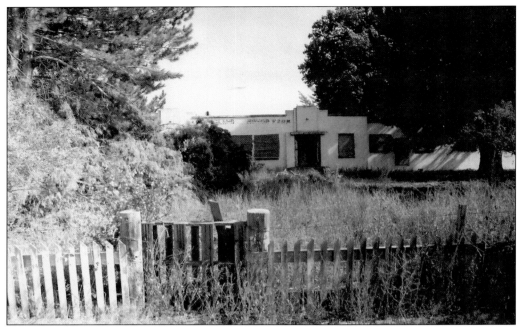

Despite its success, the honor farm was abandoned in 1974 in favor of a new farm at the penitentiary located south of Boise. Initially, the Idaho Legislature passed a resolution to sell the land to raise funds for a new cell block at the same penitentiary. Then governor John V. Evans, however, insisted that using the land to take pressure off other park areas outweighed the short-term financial advantages of such a sale. Ada County officials, also concerned about park overcrowding, asked that 135 acres of the old farm be retained as a part of the Boise River Greenbelt and for a county park. Three years later, Eagle Island State Park was dedicated. Above is the still extant prison farm administration building, and below is the Eagle Island State Park entry sign. (Above, courtesy Lois Kunkler; below, EHM.)

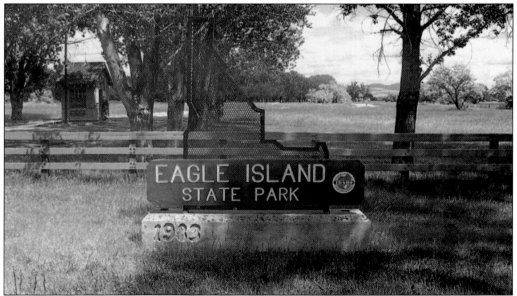

Two

Townships and Transportation on the North Shore

By 1895, Eagle's founders were already on the local scene. Eagle Island farmers Tom and Mary Aiken had purchased mainland property between the river and Valley Road (now State Street) in 1893 and built a small house there so their daughters could more easily attend school. Legendary stage driver John Carpenter retired in 1895 to settle down on property north of the Valley Road and east of what is now Eagle Road. County commissioner David Heron had a farm west of Eagle Road and north of Valley Road that he had settled decades earlier.

Aiken took the initiative to improve the area's development potential. A bridge anchored on Eagle Island would create a much needed crossroads in the center of the Boise Valley and unite Aiken's land holdings divided by the river. Aiken began a lengthy lobbying effort with Ada County officials to construct the bridge. County voters finally approved a $19,784 bond issue for the bridge in March 1902, and it was completed over both channels a year later. This sparked the development of Eagle. In 1907, the bringing of the interurban trolley from Boise to Eagle by Aiken's friend and developer Walter Pierce enhanced the Eagle boom.

Heron quickly tried to capitalize on the new bridge by platting a 48-lot Heron Township with Ada County on the northwest corner of Valley and Eagle Roads in September 1903. The only permanent result of his effort was Heron's donation of lots for a Methodist church; otherwise, he was overshadowed by the partnership of Aiken and Carpenter, who filed a plat for the Eagle Township along both sides of Valley Road on September 2, 1904. Carpenter had already donated the northeast corner of Valley and Eagle Roads for an Odd Fellows Hall, which became the settlement's social center. Eagle soon saw a hotel, a mercantile store, a bank, and a drugstore built along Valley Road, and Aiken enticed the Edgewood Baptists to move into town. Merchants and farmers built modest homes among the commercial buildings, a pattern still detectable in downtown Eagle today.

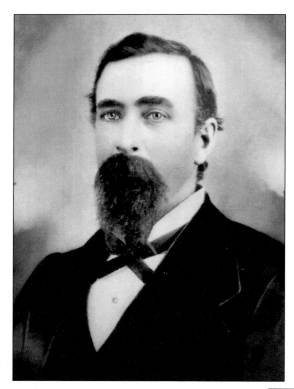

Thomas Hugh Aiken, generally considered "the father of Eagle" because most of the original site of the village established in 1904 was on land he owned, was born April 3, 1845, in Guysborough, Nova Scotia. In 1883, he married Mary Conway, 20 years his junior. The newlyweds moved to the Eagle Island property where they had five children, two of whom died in infancy. By 1900, years of hard work and shrewd investments in real estate had made them wealthy, and in 1905, Aiken built a bungalow, which still stands today, for his family in downtown Eagle. Pictured at left is Aiken in the 1870s, and seen below is Mary as she looked in the 1940s. (Left, courtesy EHM; below, Gordon Melvin.)

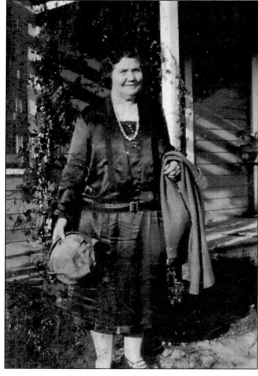

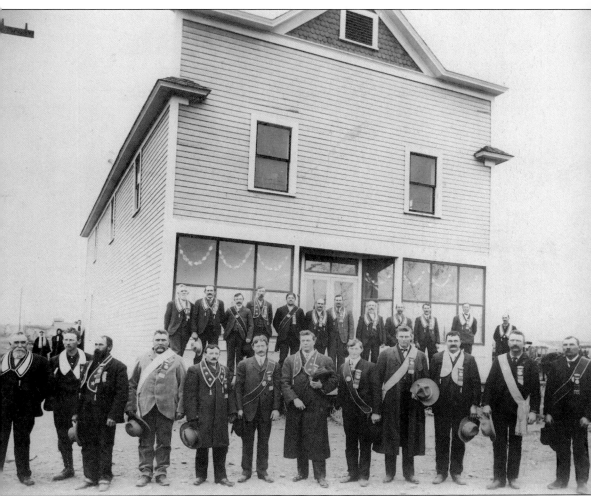

The Independent Order of Odd Fellows (IOOF) is an altruistic and benevolent fraternal organization derived from a similar British organization founded in the 18th century. The Eagle IOOF lodge was a fairly new organization holding meetings at the old White Cross School when local stage pioneer John Carpenter deeded the organization the northeast parcel of land between the intersection of Eagle and Valley Roads. In 1902, lodge members themselves built the hall, and meetings were held on the top floor while the bottom floor was used as a recreation room. Shortly after the hall's construction, the organization turned over the top floor to nine or 10 local families who did not want their children traveling all the way to Boise to attend school and were looking for a way to create a community-operated high school. (Courtesy Ron Marshall.)

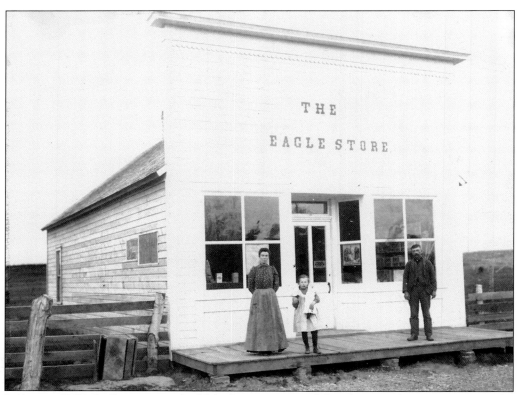

In August 1907, the Boise paper, the *Idaho Statesman*, noted that there was but one store in Eagle: a grocery store. Known simply as the Eagle Store, it opened in 1902 and was operated by Joe Raines, pictured above with his wife and daughter. E.B. Harris, Eagle's first pharmacist, purchased the store and turned it into a drugstore. Harris operated the Eagle Drug Store for 16 years, the final days of which spanned the beginning of Prohibition. At that time, whiskey could be sold by prescription only, forcing the resourceful druggist to purchase it in 30-gallon barrels. In 1922, Harris sold the drugstore to Orville Jackson, who went on to make it a landmark. Jackson's name still graces its second building's exterior. (Both, courtesy City of Eagle.)

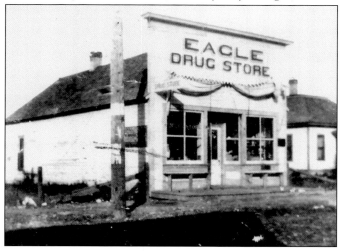

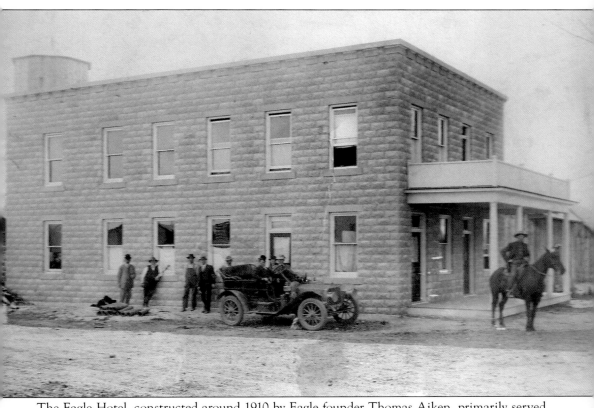

The Eagle Hotel, constructed around 1910 by Eagle founder Thomas Aiken, primarily served as temporary quarters for workers on the interurban trolley and teachers from the Enterprise School District. During this time, the hotel, nicknamed "Uncle Tom's Cabin" after the owner, Thomas Aikens, was constructed out of cement block produced locally and had 16 rooms. This photograph, taken shortly after its construction, shows from left to right, Walter E. Pierce, builder of the interurban; Tom Aiken, the hotel's builder; two unidentified men; Frank M. Gardner, the founder of the Bank of Eagle; Charlie Bays (seated in the car), Eagle's original real estate agent; and George Riley Brashears, husband of Aiken's daughter Mabel, sits astride the horse. Today, the hotel is home to various retail businesses. (Courtesy EHM.)

Eagle's first bank, organized in 1907 by F.M. Gardner of Middleton, operated out of the Eagle Drug Store. It was so successful that by the end of its first year of operations, deposits amounted to nearly $30,000. In 1910, the bank moved into its newly constructed building at the northwest corner of State and First Streets and thrived for many years. Despite its solid footing in the community, however, it could not stand up against the Great Depression. Eagle's first bank closed its doors in August 1932, with its depositors receiving every dollar they had entrusted to it. As with many small-town banks that closed during that era, the empty building became a local watering hole after the repeal of Prohibition in 1933. Dubbed the Bank Club, it served as a popular gathering place for many decades. (Courtesy Dorothy and Loyle Washam.)

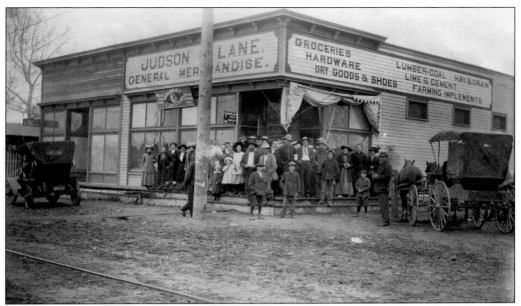

Mercantile stores, the forerunners to modern-day department stores, were plentiful during Eagle's infancy. One notable example was Judson and Lane General Merchandise. Located on land purchased from Eagle founder Thomas Aiken, this lumber and mercantile business was owned and operated by Charles Judson and James H. Lane and located across First Street opposite Aiken's Eagle Hotel. After just a few years of successful merchandising, Judson (left, below) and Lane (right, below) sold their business back to Aiken, F.H. Copeland, and W.J. Selby in April 1914, and it was renamed Eagle Mercantile. (Both, courtesy Leona Judson.)

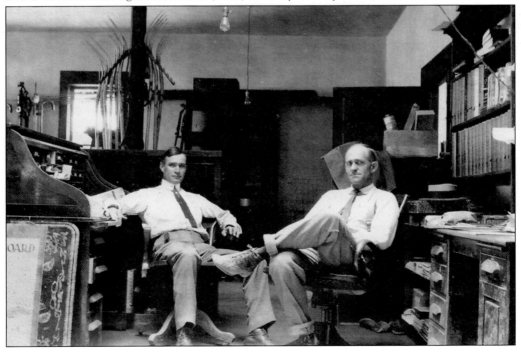

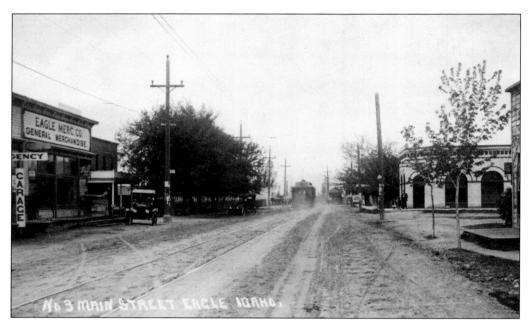

In 1891, the Boise Valley Interurban trolley system began operations. During the first decade of the 20th century, it extended its lines from downtown Boise out the Valley Road through Eagle, Star, and Middleton and across the Boise River to Caldwell. Made up of 66 miles of track, these lines provided transportation and carried light freight. In addition, fun-seekers could also day trip into Boise or anywhere else they chose along the route. One of the favorite stops for these casual travelers was the Eagle Drug Store, where Orville Jackson served ice cream and other treats at his soda fountain. In the image above, the interurban travels west through Eagle, and below, the tracks are seen stretching to the east. (Both, courtesy Patricia Hicks.)

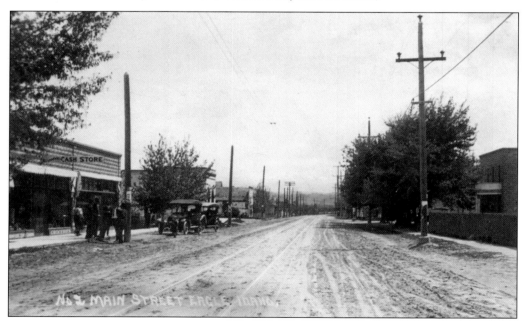

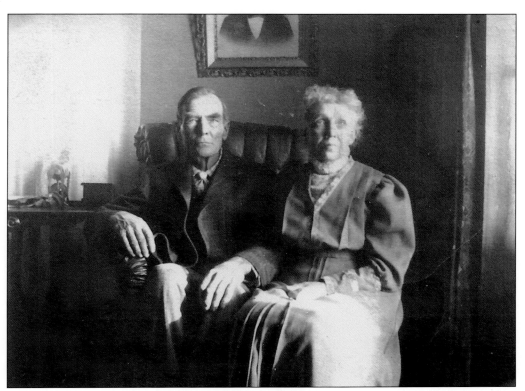

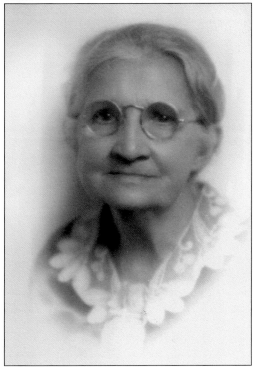

Orlando H. Bushnell retired to Idaho in the early 1900s with his wife, Ella. Their daughter and her husband, the aforementioned Charles Judson, along with her sister Elizabeth, moved with the senior Bushnells. In 1909, Orlando Bushnell purchased two acres west of Eagle and constructed a large home. Ella Fisher, pictured at right, discovered early on that she had married a man with a bit of wanderlust. Leaving Iowa in 1887 with their five children, she and her husband, George, made their way to Idaho where they traded homes every few years and eventually settled in Eagle. After George's passing Ella purchased the Bushnell residence, undoubtedly seeking the security of a permanent home. (Above, courtesy Leona Judson; right, Edith Cohen.)

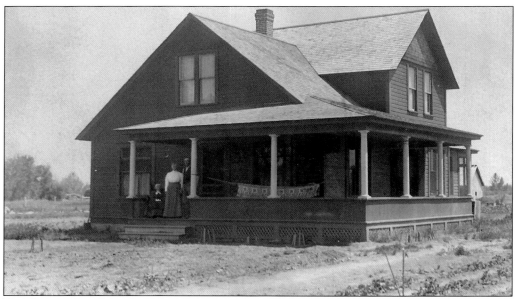

Eagle's growth reflected early-20th-century boom years in the Boise Valley, with agricultural and small-town development at an apex. The initial platting of Eagle townsites, along with the construction of the interurban streetcar line along the townsite's main thoroughfare, caused increased real estate speculation and land subdivision on adjacent property. Orlando Bushnell was one of the many who took advantage of this new land subdivision to build the cross-gabled vernacular home pictured above. After numerous sales and deed transfers within the family proper, his daughter Elizabeth, the sole remaining owner in 1914, sold the property to Ella Fisher, who is seen posing in the front garden below. (Both, courtesy Edith Cohen.)

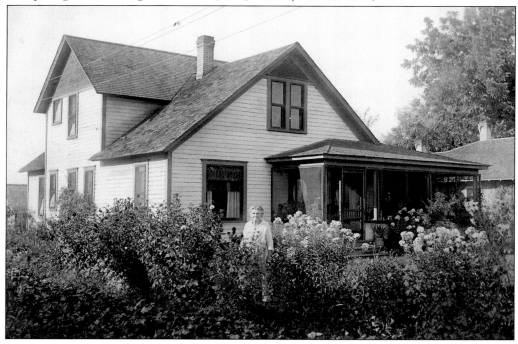

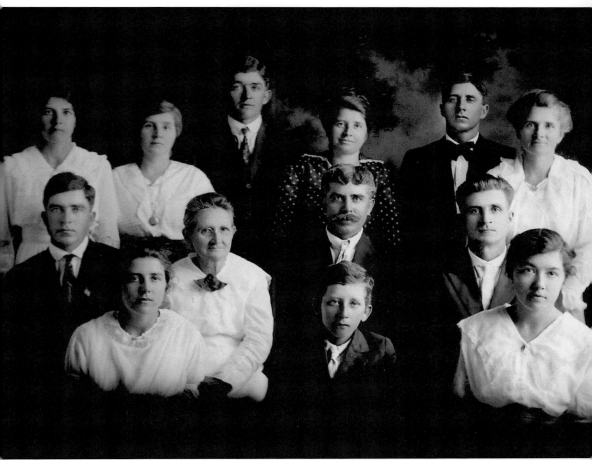

As was noted earlier, Ella Fisher and her husband, George, immigrated to Idaho with their five children. Once here they had eight more. According to family legend, Ella inherited money from her parents' estate sometime before 1918, and it was this inheritance that helped her purchase the Bushnell home, where she and four of her youngest children lived until they married. Upon her death in 1937, her estate awarded portions of the property to the four children; the elder three children soon deeded their portions to Earl, the youngest son on George and Ella Fisher, who lived there until his death in 1986. This portrait is of the entire Fisher family, sans George Sr. Pictured from left to right are (first row) Lena, Earl, and Ina; (second row) George Jr., Mother Ella, Bud, and Theo; (third row) Blanche, Maude, Brian, Lulu, Bill, and Emma. (Courtesy Edith Cohen.)

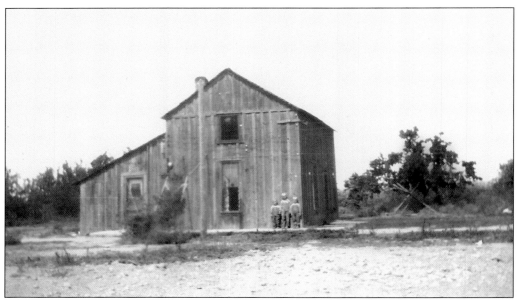

Some early Eagle residences were quite grand, and others were much simpler. Here, Donald, David, and Lee Records pose in front of their home, the Alfred and Edith Records Ranch in Eagle. The home was located near the southwest corner of Eagle and Beacon Light Roads. This photograph was taken sometime in the late 1920s. (Courtesy Edith Cohen.)

Eagle's first post office was established in 1908 in Louis E. Diehl's general store. When it was suggested that rural delivery be transferred from Boise to Star, the small community west of Eagle, rural residents protested, claiming their delivery time would be slowed. The proposed change was not enacted, and Eagle's single rural free delivery mailman, a Mr. Grabster, continued with his regular route. (Courtesy Phil Fry.)

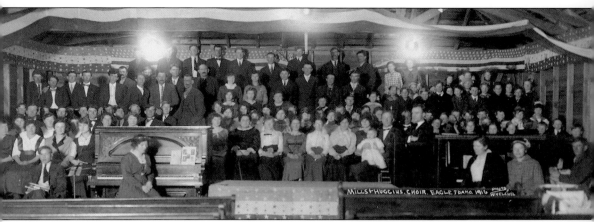

In the early 1900s, two locals constructed a building south of Eagle to be used as a community hall. It was noted for its dances, and out-of-towners came to take advantage of the absence of authority. Eagle folk did not object to the dances themselves, just the manner in which they were conducted. After a brawl in which one participant died, several of the community's more spirited citizens decided that the building could be put to better use, and it was moved to a location across from the First Baptist Church on a lot donated by Mary (Conway) Aiken. From then on, it was known as the Eagle Community Hall, and a board of control was established to ensure that it hosted only "acceptable" activities. In 1916, several Mills-Huggins Evangelistic services were held there. (Courtesy Mary Ann Taylor.)

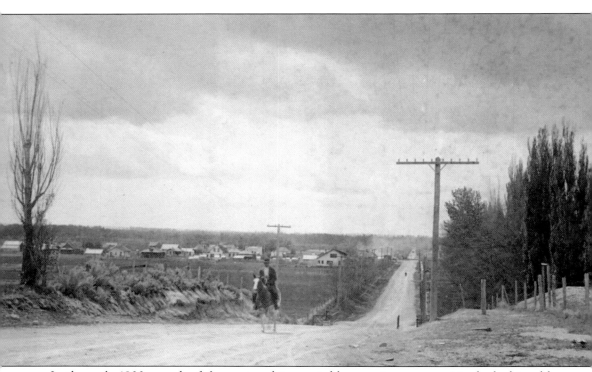

In the early 1900s, much of the west and its myriad burgeoning communities looked just like this. As this lone rider travels slowly up the dirt road that will eventually become Eagle Road, one sees in the distance the agricultural lands and small settlements that made up much of the western landscape. At the time this image was captured, electrical lines, originally brought by the interurban, were beginning to make their way into the countryside, and township subdivision that encouraged structures like the Bushnell residence was well under way. The one-room schoolhouse was living on borrowed time, and had the cameraman pivoted more to the west, one would be able to see the newly constructed Eagle Grade School on the right. At this stage, the village of Eagle was definitely on the map and would continue its march of progress, surrounded by its agricultural base, into today. (Courtesy Patricia Hicks.)

Three

Arid Land Watered by Ditches

Eagle would not exist without irrigated agriculture. First by tapping into the Boise River directly and then by bringing water from higher elevations via canals, called ditches by Idahoans, farmers in the Eagle area were able to grow a variety of profitable crops and maintain large beef and later dairy herds. The abundance of local ground water provided the domestic supply and supplemented long-distance ditch irrigation as well as improved drilling technology. Eagle grew as a convenient service point for farm families, a transportation and distribution nexus for local agricultural production, and an important food-processing center.

Truman Catlin had surprised scoffers by raising foodstuffs, beef cattle, and hogs on Eagle Island by the mid-1860s. The soil on the island and in the surrounding bottomlands was predictably sandy and could contain gravel deposits but was surprisingly rich in nutrients accumulated annually by the river. It could easily support grain crops, orchards, and pasturage for grazing stock. The broad, sagebrush-covered benchlands to the north of the river had more loamy soil and, once irrigated, were extremely fertile, as Tom Aiken's older brother Samuel Aiken had already discovered on his pioneer and very profitable Green Meadow farm located two miles east of Eagle.

As canals brought water to the higher lands north of Eagle in the 1890s, farmers began to cultivate a variety of crops, including many grains, silage, melons, and beets. As the 20th century progressed, various berries, herbs, and nursery stock also were grown. By the early 21st century, even varietal wine grapes could be found near the foothills north of the city. At least until the period between the two world wars, however, there was always a local competition between crops and pasturage supporting livestock and all other crops. Gradual mechanization of basic farming operations beginning the 1920s made the need for locally grown feed crops less acute. So did the switch, beginning about 1905, from raising beef cattle to dairying, which is today the least well documented of all Eagle's past agricultural pursuits.

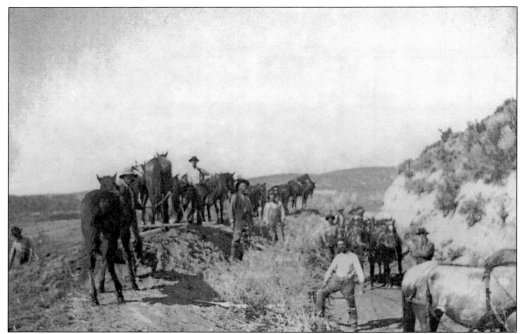

Eagle owes its founding to agriculture and, hence, to irrigation. Numerous canals and ditches, both large and small, have irrigated Eagle and its environs since its earliest days. The Farmers Union Ditch Co., based in the north end of Boise, was begun in 1894. By 1899, the main ditch was 24 miles long and, by 1902, it was able to irrigate 9,000 acres. Today, more than 140 years after the first irrigation ditch was dug in the Boise Valley, three major canals and a highway network of smaller ditches crisscross Eagle. These two c. 1906 images are of washout repairs on the Farmers Union Ditch. (Both, courtesy Rob Woodford.)

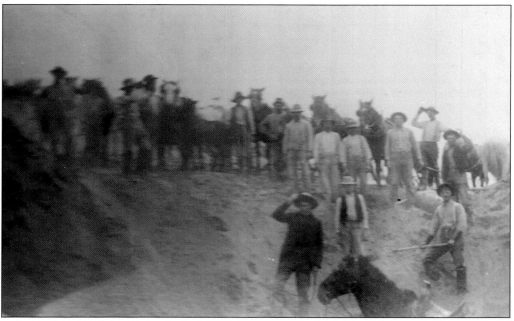

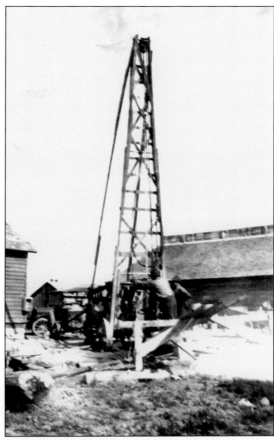

The benchlands on which a majority of Eagle resides are naturally semiarid and used to be covered by sagebrush. While early crops were largely irrigated by the ever-expanding canal system, early domestic water use required the construction of artesian wells and water tanks. Domestic windmills were also constructed to pump water and may have later been used for generating power. The image to the right is of the first artesian well being dug at the Joe Cullen Sr. residence on Floating Feather Road, and below is the same property dominated by a water tank and windmill in the mid-1920s. (Both, courtesy EHM.)

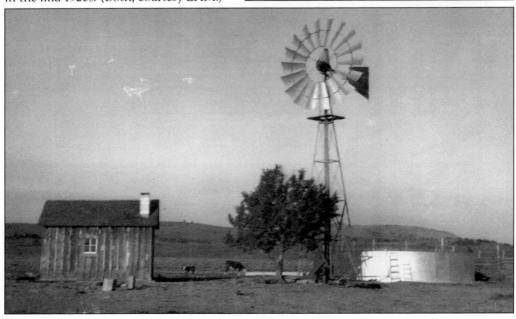

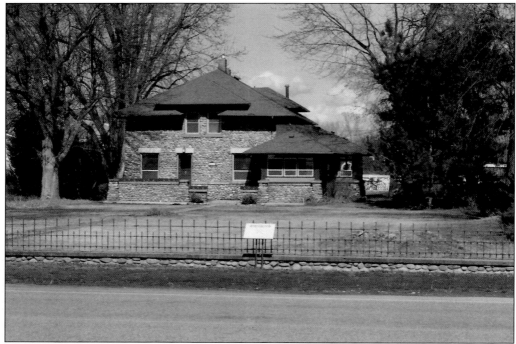
This stately home was built in 1906 by prune magnate Oliver Francis Short. It was crafted entirely of Boise River cobblestones, and its style is derived from the Classic Box form popular at the beginning of the 20th century. The Short house was listed in the National Register of Historic Places in 1980. (Courtesy EHM.)

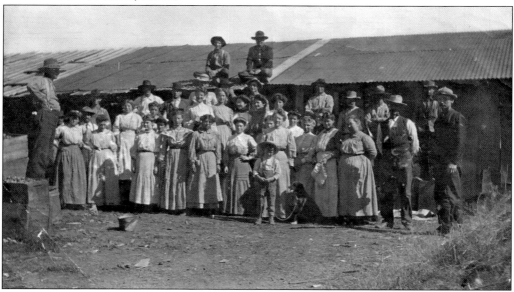
Short came to Eagle in 1874 to stay with his maternal uncle, Truman Catlin. After marrying Catlin's sister, he took over the management of his uncle's farm and eventually purchased 320 acres of it. Fifty-five of these acres became prune orchards. Short's prune-packing shed, pictured here about 1908, was located on the northeast corner of his residential property. (Courtesy EHM.)

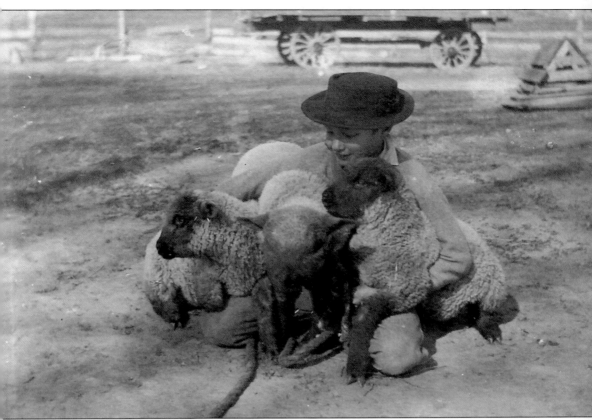

George W. Fry, an Iowa native, was an early homesteader on the mainland north of the Boise River. At the time that he first settled on his property, the country was wild, undeveloped, and bore nothing but a crop of sagebrush. After building a home, for which he had to haul lumber from 30 miles away, he cleared 12 acres of land and raised his first crop of corn. By his third year, he had cleared 25 acres and planted alfalfa, which he sold mostly to sheep men. In 1902, he purchased 1,200 head of ewes. Finding the sheep business quite lucrative, Fry introduced Shropshire sheep to the region, much improving the breed of sheep raised in Ada County. Pictured here is his youngest son, Russell, who is obviously quite taken with this trio of Shropshire lambs. (Courtesy Phil Fry.)

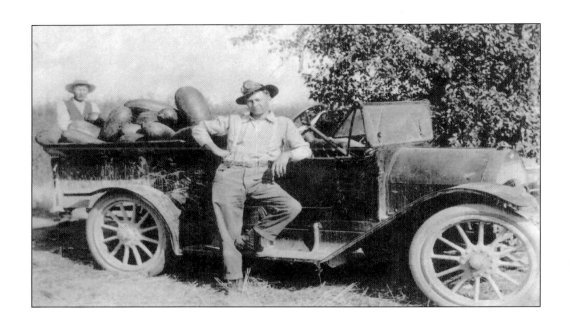

Though he began his Eagle farming career with corn and alfalfa and then branched out into the sheep business, George W. Fry planted a variety of crops over the years. One of the more prominent of these was watermelon. In the above image, Fry is seen taking backstage to a now very grown-up Russell as they both show off an early farm truck loaded with a number of their finest melons. Below, melons and a grower wait outside a Union Pacific railway car, most likely in nearby Meridian, to load their produce for disbursement to more far-flung markets. (Both, courtesy Phil Fry.)

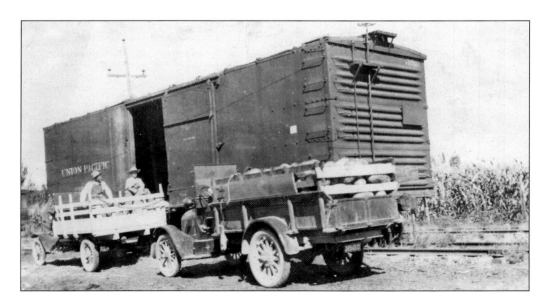

Theodore "Theo" H. Fisher, the seventh of 15 children born to Eagle pioneers George and Ella Fisher, arrived in a covered wagon from Iowa and lived his entire life in and around the Boise Valley. Contrary to George's wandering ways, 12 of the Fisher children put down roots and grew to adulthood in Eagle, with Theo being one of them. For 64 years, he lived on this Eagle ranch on Beacon Light Road and, over the course of the years, raised potatoes and numerous grain crops. While not working side-by-side with other members of the Fisher clan during harvest time, he served on the Eagle School Board and was treasurer for the Farmers Union Ditch Co. for a number of years. He was also a member of the First Baptist Church of Eagle. (Courtesy Edith Cohen.)

The Lorenzo "Ren" Marshall family moved to Eagle in 1920. Previously residents of Coalville, Utah, they moved to Eagle via Burley, Idaho, where other close family had relocated. During the flu epidemic of 1918, Ren's wife, Mary (Fewkes) Marshall, died, leaving him with six children to raise. Mary's young adult niece Nettie came to stay with the family to help, and a year later, she married Ren. This union resulted in seven additional children, bringing the total to seven girls and six boys. The family settled on 80 acres at the northeast corner of Floating Feather Road and Park Lane, where they raised cattle and farmed alfalfa, wheat, barley, and oats. At left is an image of Ren from 1936, and below is the combined Marshall brood around 1938. (Both, courtesy Ron Marshall.)

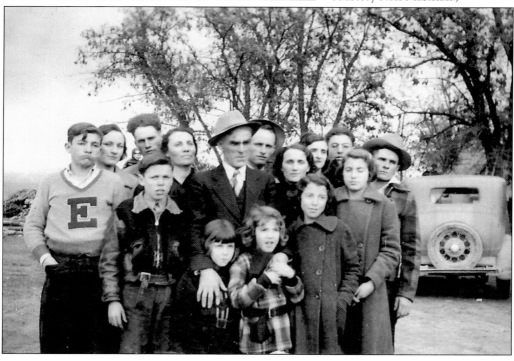

While most people today only use tents when camping, it was not uncommon for early settlers to use tents as a temporary residence while building a home. Ren and Nettie Marshall did just that while they were building a replacement home in the mid-1940s. For a time, this tent served as their temporary residence. (Courtesy Ron Marshall.)

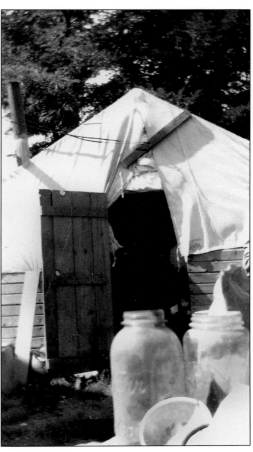

By the 1930s, the kitchen was being transformed, slowly becoming a streamlined modern kitchen. The all-electric kitchen was constantly promoted by advertisements showcasing newly designed appliances. In the 1940s, further improvements produced appliances with more designs that are streamlined and smaller proportions. Nettie's new kitchen obviously met all the modern requirements. (Courtesy Ron Marshall.)

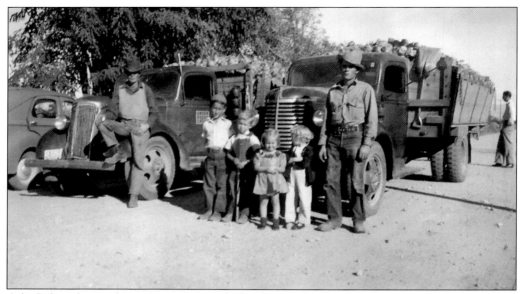

A little bit of everything was grown in the Eagle area during its formative years. Pictured here are six members of the Marshall family proudly showing off their sugar beets, harvested at the Marshall farm on Floating Feather Road around 1945. From left to right are Norm, Ron, Dale, Lucille, Maxine, and Carl Marshall. (Courtesy Ron Marshall.)

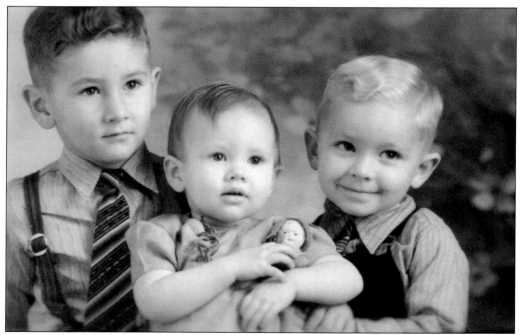

Not too many years earlier, Ron, Lucille, and Dale were dressed in their Sunday finery to pose for this professional portrait. Ron, the oldest, is on the left. He and brother Dale are flanking sister Lucy. (Courtesy Ron Marshall.)

Despite the fact that farm production grew considerably during the 1920s to the 1940s, the Great Depression severely hampered the average farmer's ability to purchase new and necessary farm equipment. Ever inventive, American farmers began designing their own farm equipment, piecing together the necessary machinery with bits and pieces of cars, trucks, and other equipment that no longer served its original purpose. Several pieces of machinery used by various members of the Fry family during this period were perfect examples of this make-do spirit. Above, Homer Fry puts his homebuilt buck rake to work, and pictured below, his Depression-made tractor rests for a moment at his father's farm. (Both, courtesy Phil Fry.)

In 1897, Louie Quong and his brothers arrived in Boise from a small village in southern China. Unlike most of their fellow countrymen, they decided to go into vegetable farming rather than mining. Since the Chinese were not allowed to own land at that time, they rented land just east of Eagle. By 1936, the property ownership ban had been lifted, and Louie and his second wife, Mabel, were able to purchase acreage in Eagle. Realizing they needed to diversify, they added dairy cows, chickens, and strawberries to their operation. The strawberry venture proved an almost immediate winner, grossing up to $1,000. After World War II, the Quongs began renting adjacent land and expanded their strawberry operation. They also hired many of the local kids to help at harvest time. Above, Mabel Quong and her son Peter pose on a strawberry farm tractor. (Courtesy Paul Quong.)

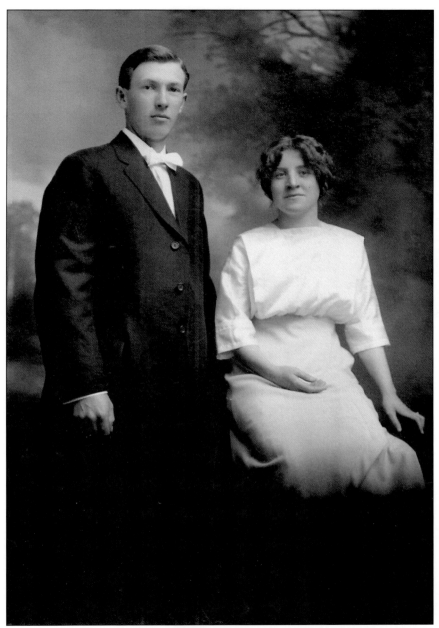

Walter P. Stillwell Sr. was one of Eagle's earliest natives. Born February 4, 1892, in Eagle, he was one of the founders of the Dry Creek Soil Conservation District. He married Maude Fisher in December 1913, and the two of them presided over one of the largest cattle ranches in the region. During the course of his career, Stillwell was a member of the Payette Cattlemen's Association, a charter member of the Ada County Sheriff's Posse, and a past Noble Grand of the Eagle IOOF. His wife, one of the 15 children born to George and Ella Fisher, was a member of the Carpenter Rebekah Lodge, the Women's Society of Christian Service of the Methodist Church, and the North Side Extension Club. This formal portrait was taken early in their marriage. (Courtesy Colleen Cahan.)

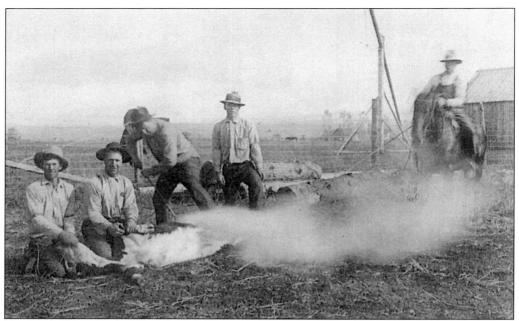

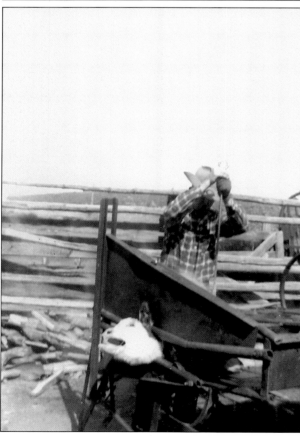

Livestock branding is a technique used for marking livestock so as to identify its owner. In the American West, branding evolved into a complex marking system still in use today. The unique brand of each owner meant that livestock owned by multiple ranches could graze freely upon the open range and still be easily separated. Free-range or open-range grazing is less common today than in the past, but branding still has its uses, specifically in proving ownership of lost or stolen animals. Both of these images are of branding operations on the Stillwell ranch, above in the early to late 1930s and the other much later. (Above, courtesy Ronda Hatfield; left, Colleen Cahan.)

Walt Jr. (left) and Glenn Stillwell twirl their hats in enthusiasm while riding their bulls around 1933. As noted previously, their parents, Walter and Maude Stillwell, were both farmers and cattle ranchers. This image was captured by their grandfather at the Stillwell home on State Street just outside the barn. (Courtesy Colleen Cahan.)

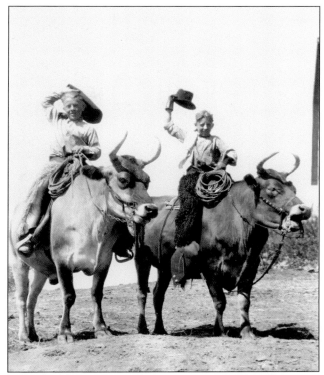

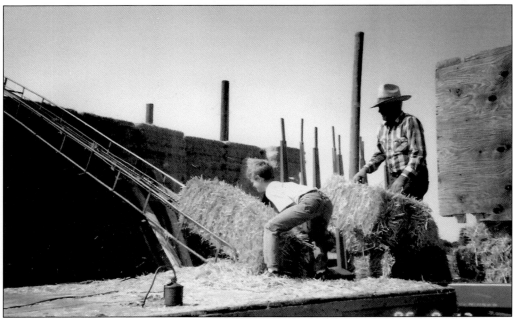

Though Eagle is far from being the agricultural center it once was, some remaining farms continue to grow and harvest a variety of crops. Here, Fred Kunkler and his grandson Cameron load hay bales grown on the same land the Kunkler family had been working for decades onto a conveyor belt in 1996. (Courtesy Lois Kunkler.)

In the 21st century, Eagle's farming heritage has morphed into the type of agricultural pursuits that are well suited to its increasingly sought after upscale lifestyle. In a move that was undoubtedly inevitable, the Eagle Chamber of Commerce hosted its Inaugural Eagle Food and Wine Festival on September 29, 2007. The previous evening had also played host to an Eagle Food and Wine gala held at Casa D'Aquila Vineyards, 11 acres of vines belonging to Eagle's chief vineyard promoters, Lloyd and Judy Mahaffey. The gala, which held a silent auction to raise funds for the Special Olympics World Winter Games, was beset by foul weather, forcing all the attendees of the $150-a-person gala into the elegant home of their hosts, but spirits were apparently not dampened. But in the beginning, this festival foretold of a agrarian ideal that is still in the making today. (Courtesy EHM.)

Four

Processing an Abundant Harvest

Eagle was one of Idaho's major food processing centers from 1907, when the interurban trolley began to haul freight in and out of the community, to 1989, when urbanization, national grocery chains, and a spectacular fire brought an end to three of the major local food industries. The earliest industrial food processing in Eagle involved milk products. In 1907, the Boise *Statesman* reported that a new creamery in Eagle was getting milk from 500 cows and producing 225 pounds of butter daily. In 1913, a cheese factory also opened up in Eagle as a branch of a larger Meridian operation. Unfortunately, creameries are the least well documented of any Eagle industry, likely because they were dominated by Meridian interests.

Eagle's meatpacking plant opened in 1913 and was expanded several times thereafter. Called the Boise Valley Packing Company, the facility was located on the north channel of the Boise River, west of Eagle Road, probably because the river provided easy disposal of industrial waste. It processed both hogs and beef cattle and marketed its Eagle Brand of meats to smaller grocery stores. By the 1940s, it was Eagle's largest employer. The demise of mom-and-pop grocery stores caused its closure in 1989.

Large scale milling of grain began in Eagle in 1920 with the building of the Eagle Flour Mill near the southwest corner of State Street and Eagle Road. The large, landmark building produced and marketed its own brands of flour. Stricter health and environmental codes forced the mill to switch to producing animal feeds during its last years. It was closed by early 1977 and razed in 1984.

An indication of how long Eagle remained rural was Reid Merrill's founding of an egg farm just east of the downtown in 1952. The egg business prospered and expanded to meet the demands of local chain markets; in the 1960s it was largely automated. Merrill's egg farm came to sudden end on November 30, 1989, when Eagle's largest fire destroyed most of the facility and 250,000 hens. The Merrills then rebuilt their facility in Emmett.

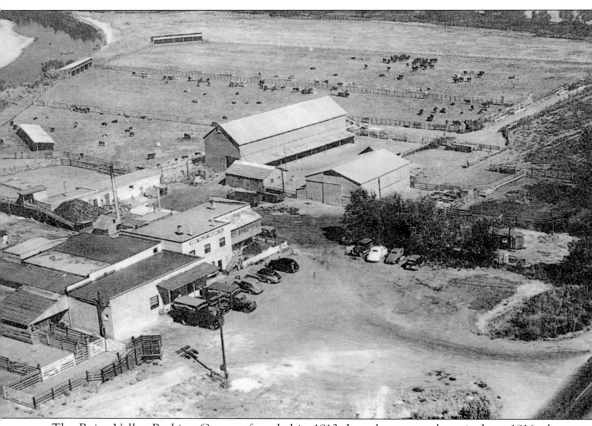

The Boise Valley Packing Co. was founded in 1913. Just three years later in June 1916, the completion of several major additions had trebled production capacity. The greatest handicap met by plant employees was the effort to turn out finished meat products fast enough to supply the remarkable demand. In February 1928, a fire in the plant did more than $25,000 in damage. The plant's riverside location also made it vulnerable to spring floods, and over the years, high water often disrupted operations. In the 1940s, the plant was Eagle's largest employer and one of its most recognizable landmarks. It closed in June 1989 after producing and marketing its "Eagle Brand" sausages and lunch meats for more than 70 years. Above is a c. 1945 aerial view of the plant, its outbuildings, and surrounding pastures and holding pens. (Courtesy EHM.)

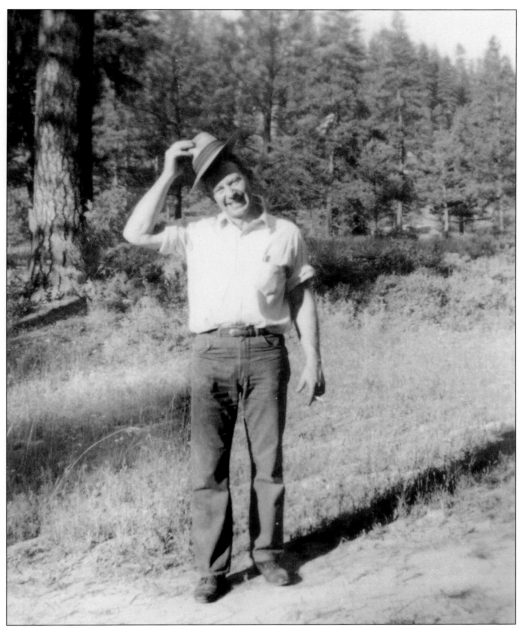

Otis Young moved his family to Eagle around 1945. At that time, they moved into the smaller of the two plant apartments that were on site. Ernest Parrish and David Callender were the owners, and Otis worked a number of jobs. He drove various trucks when a driver was needed, filled in when someone was absent, provided security, and performed maintenance duties. He slowly learned the whole business and eventually became a partner. Later in his career, after selling a home he and his wife had lived in after moving away from the packing plant, they moved back into their old apartment and completely remodeled it. During the 1940s and 1950s, the family had to walk down a cold cement hallway to a bathroom shared by both apartments, so their major improvement was the addition of a bathroom. (Courtesy Vicki Nielson.)

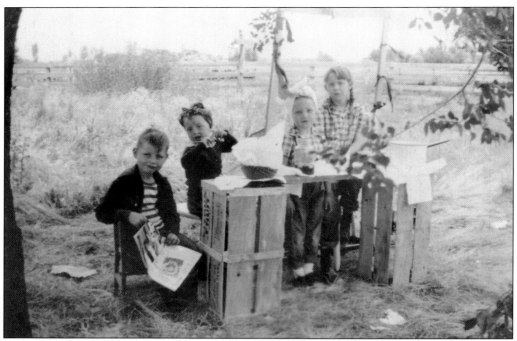

The children who lived on the packing-plant grounds loved building Kool-Aid stands on extra hot days. Above, John Parrish (son of then owner Ernest Parrish) and Judy, Vicki, and Peggy Young prepare to peddle their Kool-Aid to the many plant employees. In the photograph at left, from left to right, Vicky, Judy, John, and LaMar Jessen, whose father and grandfather both worked for the plant, pose in front of the artesian well site, which was in a little grass oasis surrounded by cinder driveways. According to Vicki Nielson (née Young), this was always a great place to get a drink of water on a hot day. (Both, courtesy Vicki Nielson.)

Pictured at right, Vicki and Judy Young stand in front of the loading dock for the delivery trucks. The dock had a smooth cement surface that was perfect for roller-skating. In addition to skating, they would eagerly wait there for the ice delivery truck. Sometime, the driver would chip ice off the giant blocks for them, and they would put it in a cloth sugar bag and break it into bite-sized pieces against the cement. Below, trucks are parked at the loading dock around 1945. In the background is the area where cattle trucks unloaded the animals that were brought for slaughter. (Both, courtesy Vicki Nielson.)

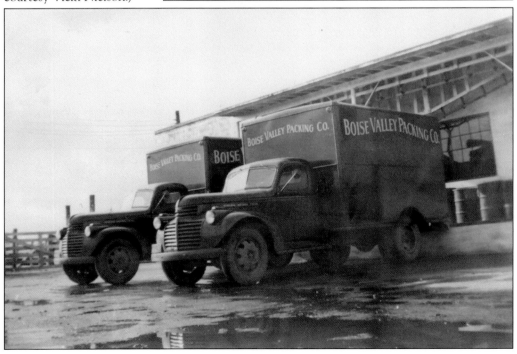

Kenneth Russell was a cattle buyer for the packing plant. His son Jack also worked for the plant, and he and his family moved into the large apartment when the Youngs moved out into a new brick home. Ken was burned badly in a weed-burning accident but managed to save himself by jumping into a nearby vat of water. (Courtesy Vicki Nielson.)

Otto Paul was the cattle feeder when the Young family first moved to Eagle. He often gave the children rides in the wagons as he fed the cattle. They would sit on a wooden sled that he used for hauling barrels of hog hair to the river and drag their feet in the dirt to make designs. (Courtesy Vicki Nielson.)

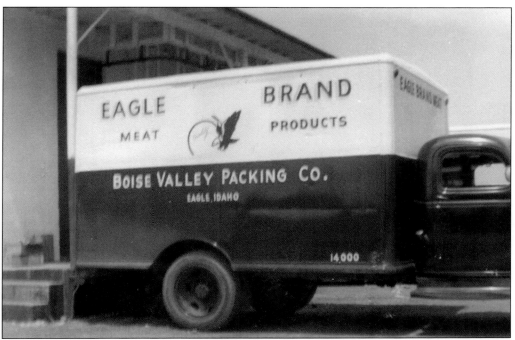

The phrases Eagle Brand Meats and Eagle Brand Meat Products spoke to the quality of the Boise Valley Packing Co. output. These tags were duly emblazoned on the company's eye-catching red-and-white trucks and its regular advertisements in the early local weeklies. (Above, courtesy Vicki Nielson; below, EHM.)

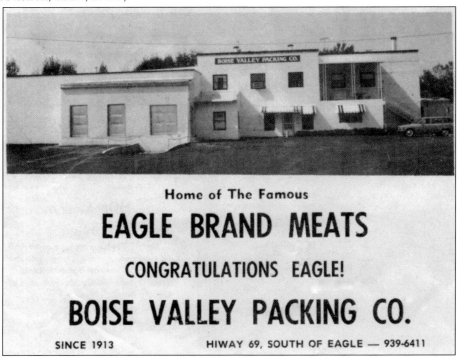

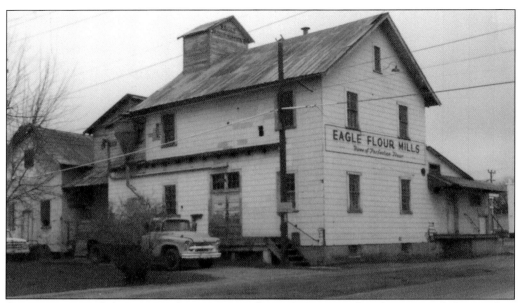

Grain was one of the principal crops grown by early Boise Valley farmers and this made a gristmill an essential industry. By 1900, a number of mills had sprung up throughout the valley, but none had been built in the Eagle area. The Eagle Flour Mill was finally built in 1920 next to the First Baptist Church of Eagle. There was an early, frequent turnover of managers, and in 1925, the company's name was changed. Walter Long, the mill's longest serving manager, bought it in 1936 and changed the name back to Eagle Flour Mill. The image above was taken by local watercolor artist Larry Walker, who then used it to create the painting below. (Both, courtesy Larry and Jean Walker.)

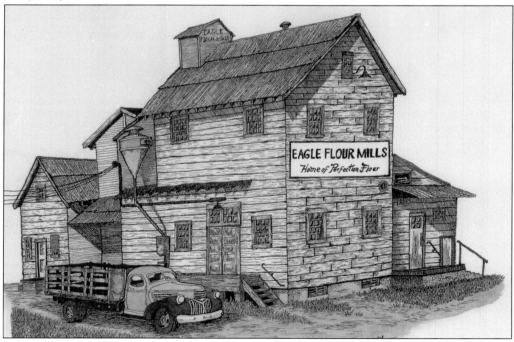

Over the years, the Eagle Flour Mill sold flour under a variety of brand names. In 1965, Sam Birnbaum bought the mill from Walter Long and built the Farm Center across the street. Four years later, Lou and Judy Mendiola bought both businesses and ran them for the next nine years. They initially milled flour for human consumption, but government regulations forced them to reconsider, and they turned exclusively to milling feed for animals. In February 1977, the two buildings and their contents were sold at public auction. For a time, the Farm Center housed a furniture store, and there were plans to create a small shopping mall in the mill building, but that proved too costly, so it was demolished in 1984. (Right, courtesy City of Eagle; below, Eagle Paint Store.)

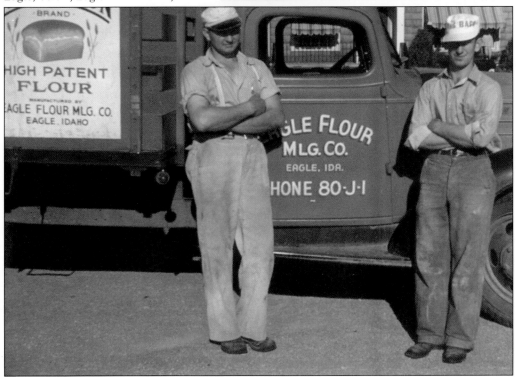

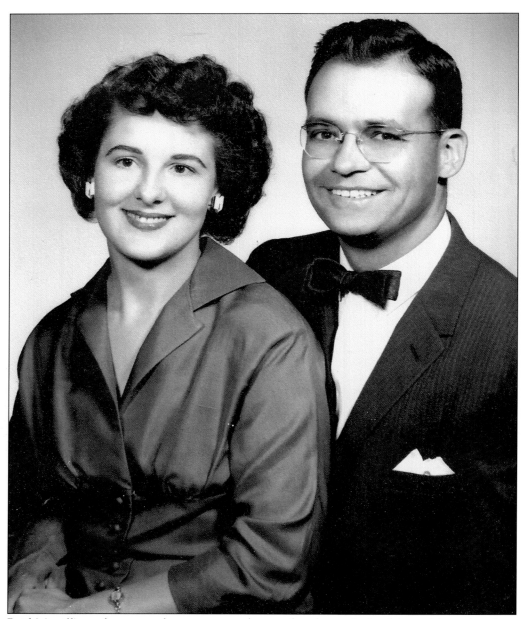

Reid Merrill's poultry career began at an early age when he worked at his uncle's poultry farm during his teens. Further experience came when he worked at the university poultry farm while attending the University of Idaho. After graduation, he spent three years in the Army during World War II and then returned to marry Theo Jensen, a girl he had met in college. As he continued on his career trajectory, he and Theo had two children and eventually settled in Eagle to run their own poultry farm. Shortly after the birth of their third child, Theo succumbed to leukemia. Reid later married Beverly Craycroft, a young widow with a child. Beverly and Reid then added two more children to the Merrill brood, and Beverly added the responsibility of keeping the books for the growing business to her many homemaking duties. This is a professional portrait of Reid and Beverly from about 1957. (Courtesy Beverly Merrill.)

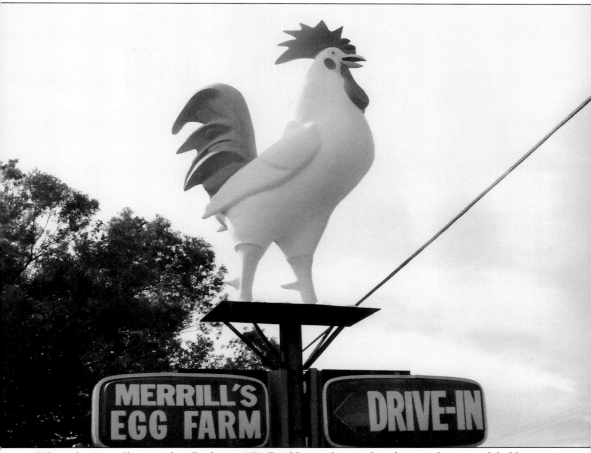

When the Merrills moved to Eagle in 1952, Reid began his poultry farm with a remodeled barn, one 30-foot-by-80-foot chicken house, and 1,000 laying hens. At that time, the eggs were sold to a local dairy and a buyer in Nampa. For its first 14 years, the business was a family affair, then in 1966, Farrin Farnworth was taken on as a partner, and the egg farm became Merrill Egg Farm, Inc. At its peak, the operation was made up of 225,000 to 250,000 laying hens, five laying houses, a large processing center, numerous chick pens, and a salesroom. It was the main supplier to Albertson's, M & W Markets, and Associated Food Stores. On November 30, 1989, tragedy struck when an electrical malfunction caused a fire to break out in one of the five laying houses. About two-thirds of the complex was destroyed, and the Merrills decided thereafter to move the operation to Emmett. (Courtesy EHM.)

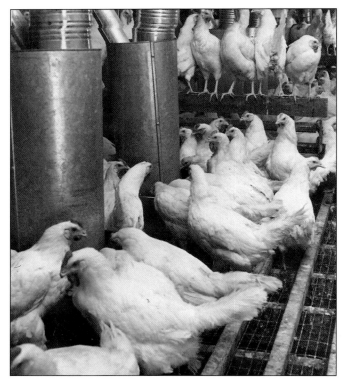

The egg farm was innovative from the beginning. By the 1960s, eggs were being gathered automatically on belts, and the chickens were fed and watered automatically as well. At that time, the farm could accommodate 80,000 chickens, and the growing and laying hens were managed by lighting systems in the large, windowless buildings. Each day saw the production of approximately 3,000 dozen eggs with a normal workday starting at 7:30 a.m. and ending at 4:30 p.m. At left, some of the egg farm's then 80,000 layers move about with relative ease, and below, Clara Dewey Paul works with the egg vacuum. (Both, courtesy Beverly Merrill.)

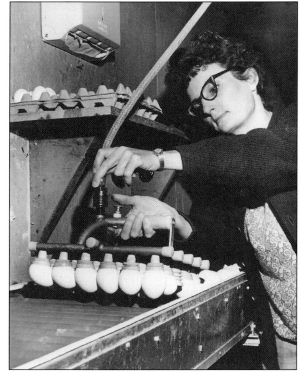

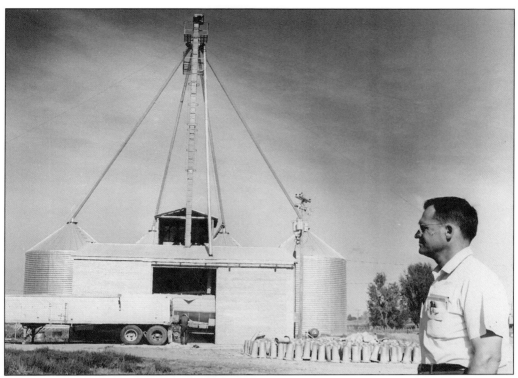

Reid Merrill stands in front of the feed mill, built in 1967. It included its own bulk storage tanks, elevator, and push-button controls. Reid tried to buy as much of his grain locally as was possible, feeling that the dollars spent locally would help area farmers have a sound market for their grain. (Courtesy Beverly Merrill.)

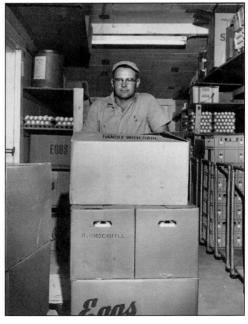

Merrill Egg Farm, Inc., came into being in 1966 when Farrin Farnworth was taken in as a partner. Farrin had been an employee for four years prior to the incorporation and had learned the poultry business from firsthand experience. Here, he poses with boxes of eggs on their way to various sellers. (Courtesy Beverly Merrill.)

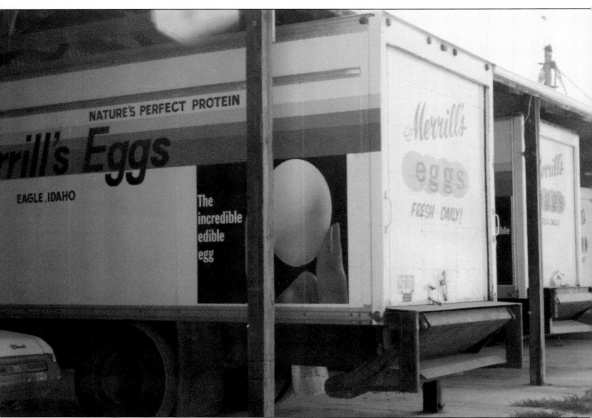

Of all the commonly consumed foods, eggs contain the highest amounts of cholesterol and people have long debated their value. According to many nutritionists, however, eggs have been unduly maligned since they are one of nature's highest-quality sources of protein. Also, the biggest influence on blood cholesterol level is the mix of fats in the diet, not how much cholesterol one consumes in food. Historically, concerns about cholesterol levels peaked in the 1970s, and the American Egg Board, a nonprofit marketing organization funded by America's egg producers, looked for a way to counter this negativity via advertising. The result was the promotional slogan "The Incredible, Edible Egg," an immediately recognizable catchphrase devised by advertising agency Campbell Mithun in 1977. Taking advantage of its positive branding, the Merrill Egg Farm delivery trucks proudly displayed this advertisement as they delivered their product to their markets. (Courtesy Beverly Merrill.)

Five

From Blacksmithing to Industry

Industry in Eagle is synonymous with the Cullen family who, over three generations, evolved from blacksmithing to machinist and mechanical work, on to invention and industrial production. The Eagle patriarch of the family, Joseph W. Cullen, started a small blacksmith operation near his home in 1917, just as mechanization was beginning to impact local farmers long reliant on horse and mule power. Cullen moved with the times. In addition to blacksmithing, he would fabricate implements for tractors, build stock trailers, and tow and do body work on automobiles. From the 1920s to the 1940s, his blacksmithing gradually became machine shop and mechanical work.

Under Joe Cullen's descendants, two major local industries would grow out of this family business. In the 1960s, his son Joey Cullen developed adjustable, telescoping metal gates and stock pens. This resulted in the thriving Adjusto-Gate business, which was eventually sold and has many imitators today. In the 1970s, Joe Cullen's grandson Les Cullen invented the Fabco stove that fit inside standard fireplaces. A national market developed for this product until stricter clean air standards made Cullen's design obsolete.

Although the Cullen family of mechanics is featured exclusively in the images that follow, the Eagle area also had its share of self-reliant farmers with their own machine shops. Usually, they took advantage of the new internal combustion engine to create farming tools for themselves and their neighbors that increased productivity. This kind of homegrown ingenuity was particularly prevalent during the Great Depression, when few could afford manufactured advances, and during World War II, when there was very little manufacturing done that was not war related.

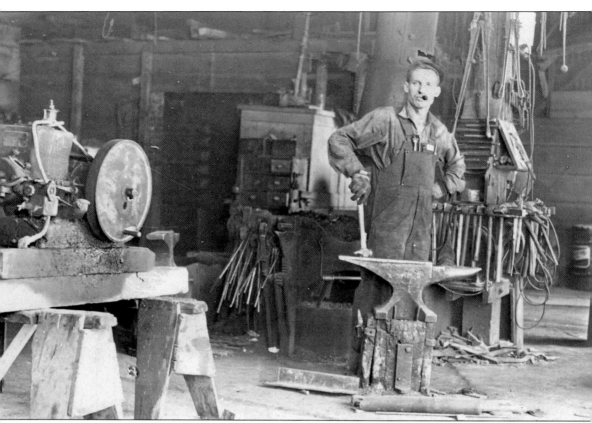

Blacksmiths have been plying their trade for over 3,500 years. Their job is to create objects from wrought iron or steel by forging the metal, that is, by using tools to hammer, bend, and cut these alloys into a desired shape. Blacksmiths produce objects as diverse as gates, railings, furniture, sculpture, tools, agricultural implements, cooking utensils, and weapons. This iconic image is of Joseph "Joe" W. Cullen Sr., the Cullen family patriarch. Though his first venture in Eagle was a cement shop, Joe longed to become a blacksmith and to that end, he borrowed an anvil, a post drill, and blacksmith's forge, and in 1920, he set up a blacksmithing operation in a small shop near his Eagle home. Soon thereafter, he bought out an already established local blacksmith shop and expanded that business, which, by then, was a growing concern. (Courtesy Les Cullen.)

Joseph William Cullen Sr. was born August 14, 1896, in a log cabin near Butte, Idaho, to Nellie Mae and Leslie E. Cullen. His parents moved frequently in search of steady employment and, while Joe was still a baby, moved to Nampa, Idaho, where Leslie was finally employed in a drugstore and grocery. By the time Joe was four, the family had moved to Emmett, Idaho, later settling in Brownlee for nine years to farm 120 acres. They arrived in Eagle in 1913. Joe, as a young man, is pictured at right, and his father, Leslie, is pictured below. (Both, courtesy Les Cullen.)

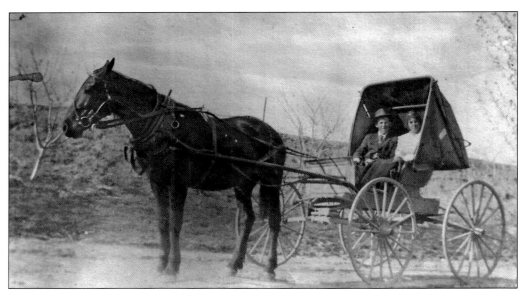

In 1917, Joe met his future wife, Blanche Fisher, another of the children of George and Ella Fisher. She had also grown up in the Eagle area and had many fond childhood memories. In this photograph, she and Joe enjoy a buggy ride shortly before their marriage in August 1917. (Courtesy EHM.)

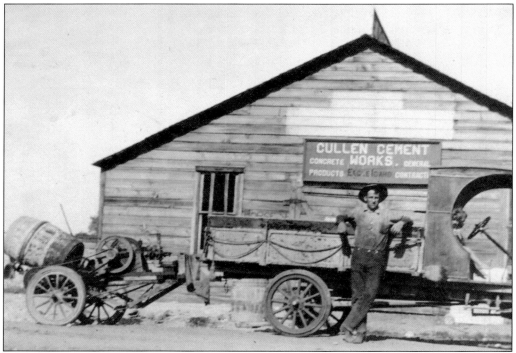

Joe Cullen's cement shop was located on Eagle Road across from where McDonalds now stands. This was his business before buying out a Mr. Chilcott's blacksmith shop. Seated in the truck are two of Joe's children—Roy and Thelma Cullen—with his wife, Blanche Fisher Cullen. (Courtesy Les Cullen.)

The making and production of cement at the time of Joe Cullen's original enterprise involved much heavy labor. In the image above, Joe and Warren Eytcheson pull a cement mixer on skids behind a wagon on their way to collect the rock needed to make cement. (Courtesy Mary Ann Taylor.)

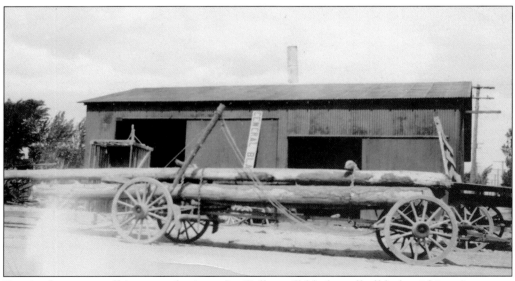

Despite the success of his cement business, Joe Cullen still felt the pull of blacksmithing. As soon as he was able, he bought out the local blacksmith shop owned and run by a Mr. Chilcott, or "Chilly." This photograph is of that shop before it burned down in 1928. (Courtesy Les Cullen.)

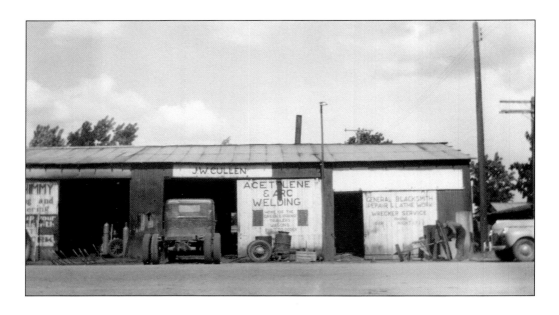

After purchasing Chilly's shop, Joe had almost more work than he could handle. As a result, he employed just about everybody that came along. In addition to the more common blacksmithing and machine work, he started building stock trailers in 1920. Two years later, he needed to build an addition, and acetylene welding was installed in 1926. He also built hay derricks and everything else a farmer could use. Then on one evening in 1928, a fire broke out. His shop, tools, and records were all destroyed. By then, however, he was firmly established and well respected, and his creditors came in and paid up, enabling him to build again. (Both, courtesy Les Cullen.)

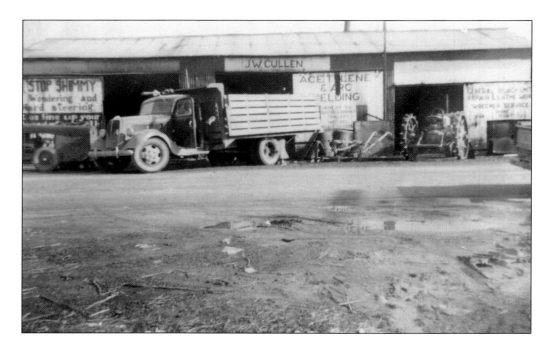

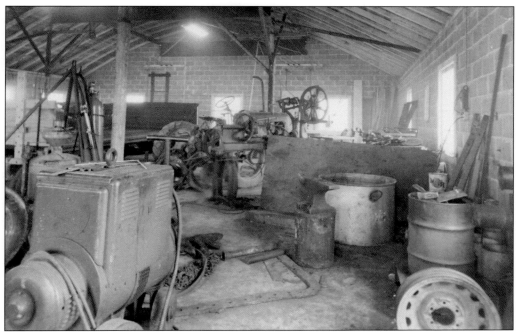

In 1945, a big, separate machine shop was built. That shop was used to repair and make tractor attachments and hoists as well as adapt late-model farm machinery for use as tractors. A peek into that shop quickly demonstrated that Joe Cullen had come a long way since starting with a borrowed anvil, post drill, and blacksmith's forge. (Courtesy Les Cullen.)

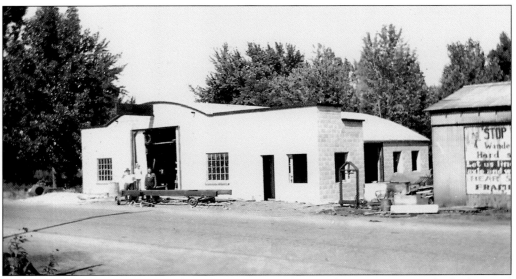

Pictured here is the new 1945 machine shop near completion. This was to remain the facility used by the Cullens until the 1970s, when their business went in an entirely different direction. The shop was incorporated in 1953, and Joe's sons Joey and Roy were made stockholders. (Courtesy Les Cullen.)

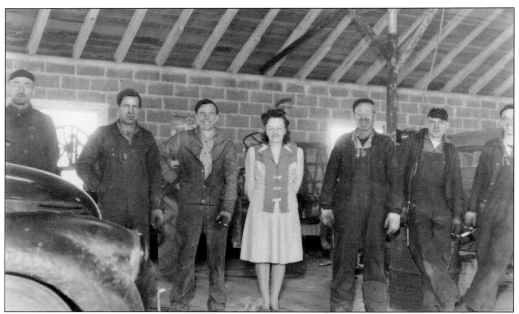

Shortly after the new Cullen machine shop opened for business, it was featured in Boise's daily newspaper, the *Idaho Statesman*. Here, *Statesman* reporter Vivian Prestwich poses inside the new shop with machinists, from left to right, Ralph Johnson, Fred Edwards, Jim Buchanan, and Joe, Dick, and Roy Cullen. (Courtesy Les Cullen.)

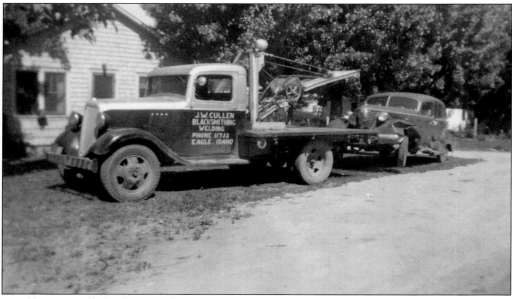

In addition to all the farm machinery work performed in the Cullen shop, its employees were often called upon to come collect the automobiles whose owners had somehow managed to park somewhere other than originally intended. Here, the shop truck is once again retrieving a car that needs some tender, loving machine-shop care. (Courtesy Les Cullen.)

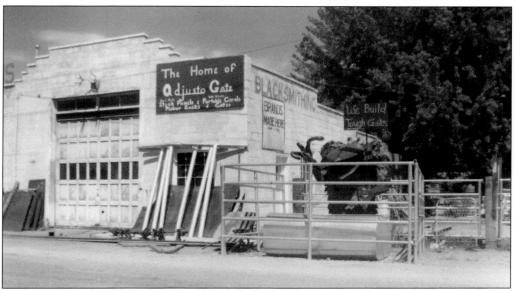

In the mid-1960s, an Eagle farmer contacted Joey Cullen, then owner of the Cullen Machine Shop, regarding his need for some gates fabricated out of two-inch standard pipe. This request led to the formation of Adjusto-Gate. Home of the adjustable telescoping gate, this offshoot of the original blacksmith business produced a variety of gates, temporary corrals, holding pens, and pick-up racks that were first designed to meet the needs of the local farming community and then advertised to a larger clientele. Above is the Adjusto-Gate shop, and pictured below is an Adjusto-Gate truck loaded with gates ready to be shipped to parts unknown. (Both, courtesy Les Cullen.)

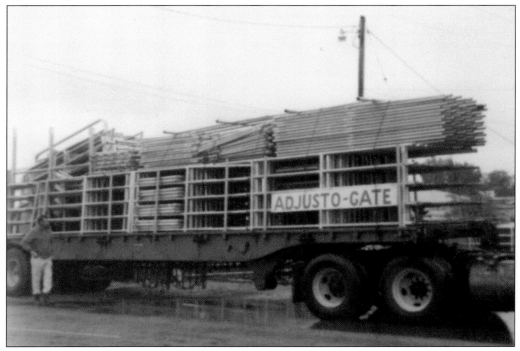

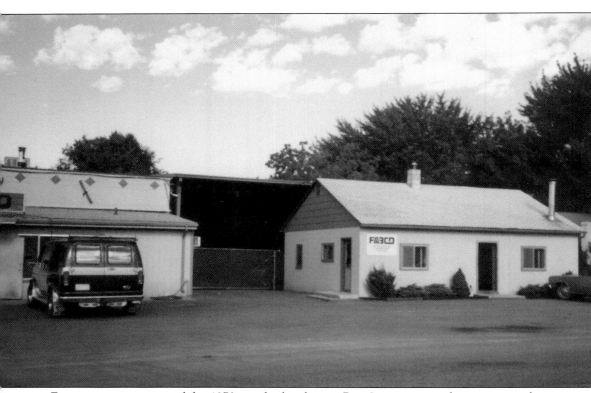

Energy was a concern of the 1970s, and a local man, Ron Larsen, wanted to put a woodstove in his fireplace, but his wife said it would be ugly and would not allow him to install one. Ron came to Les Cullen with his problem, and Les designed a fireplace insert on a restaurant napkin as the two drank coffee. While being fabricated in Cullen's shop, word got around town, and the locals began stopping by to see this new device. Cullen got enough orders from these casual drop-ins that he began thinking about how he might advertise his invention. He called the local television station and told them about what he was developing, and they ended up featuring him in a nightly news report. The next day, his phone was ringing off the hook with orders. Before he knew it, interest in his fireplace insert had spread across country, and the small Fabco Co. grew from five employees to over 100. (Courtesy Les Cullen.)

Six

Uplift 10 Miles from Boise

Education may rightly be seen as a primary rationale for founding Eagle. With volunteer labor and modest taxes, Eagle-area residents founded a school district in 1899, grew it to a K–12 institution, and maintained it until 1953, when district consolidation merged Eagle with neighboring Meridian School District. Like they did for many rural towns, Eagle's schools played a crucial role in forging community ties and identity through volunteer efforts, intramural sports, and cultural activities. Eagle's loss of its own high school from 1953 until a new Eagle High School was opened in 1995 was initially a terrible blow to the community; however, local volunteer energies were eventually redirected into such institutions as a fire district, a public library, and a new municipal government. Institutions such as these were to help to create a very different suburban Eagle.

Two rural-area churches, those of the Methodists and Baptists, predated the founding of Eagle and were lured into the community by donations of property from the town's developers. Several other churches followed, including the Seventh-day Adventists and the Nazarenes, either through local initiative or with help from coreligionists in Boise. Significantly, neither of Boise's most socially prominent denominations—the Episcopal and the Presbyterian—ever came to Eagle. As the 20th century progressed, however, pioneer churches in Eagle were overshadowed by denominations reflecting the large western migration into the area.

The two denominations with the most Eagle adherents today—the Latter-day Saints (Mormons) and the Catholics—both got late and modest local starts in the community in the 1920s and then grew immensely after World War II. In the late 1990s, the Catholics merged their Eagle and Meridian congregations to create the largest parish in Idaho. They also have a new medical complex and low-income retirement facility within downtown Eagle. Likewise, the Mormons, who have built large congregational facilities in several Eagle locations, are now planning a new temple complex on unincorporated land between Eagle and Meridian.

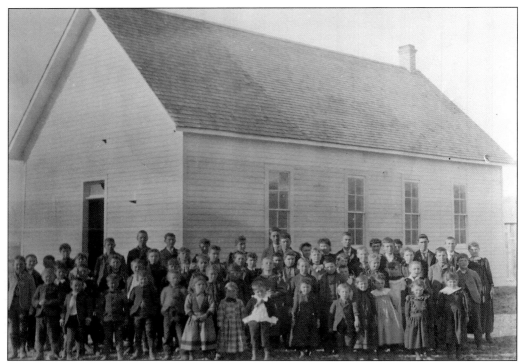

Early in the 1890s, Eagle-area settlers realized that they needed to establish schools for their children. A small school existed at Green Meadow to the northeast, seen above, but it quickly became overcrowded and was three miles distant. In 1899, William Goodall, superintendent of the Dry Creek Ditch, and local resident D.O. Stevenson petitioned the Ada County Commissioners to form Enterprise School District No. 12. At first, the creation of the new school was resisted by some local farmers who did not want to pay to support it. Nevertheless, Goodall and other fathers built the new one-room school, pictured below, and had it ready for classes in 1900. (Above, courtesy EHM; below, Les Cullen.)

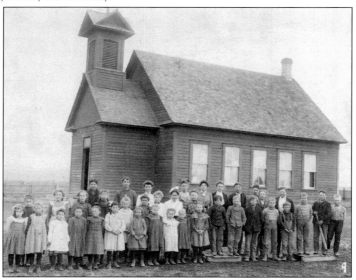

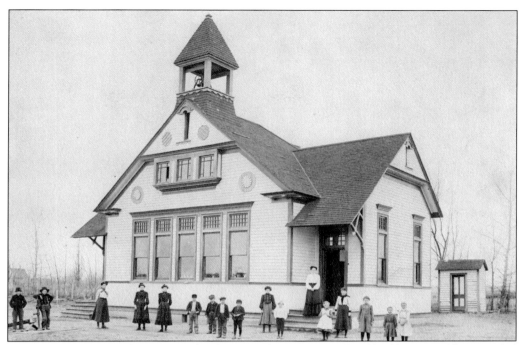

Although most late-18th-century schools were only one room, school buildings quickly expanded to include two or four rooms with two grades in each room. By 1915, grade schools of diverse size in the Eagle area included Pleasant View, Linder, Eagle Grade School, and Brookside. Linder School, which was located on Valley Road to the west of River Street, is pictured above. The interurban had a stop right in front of the school, and many children rode the trolley to class. Judging by the visible architecture, the image below is of one of Linder's classrooms. (Above, courtesy Esther Burkheimer; below, Karin Morley.)

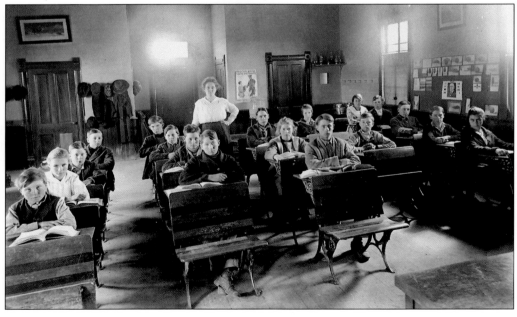

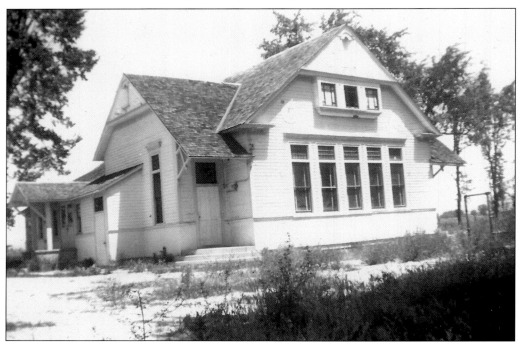

Pleasant View School, an early public school, was located on Beacon Light Road between Linder and Park Lane. It was purchased by the Church of Jesus Christ of the Latter-day Saints in 1949 and used as a church until 1962, when a new church house was built on West State Street. (Courtesy Clare Walker.)

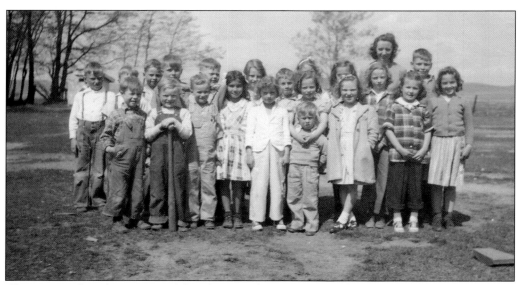

Class pictures have been a part of the educational experience for a long time, and Eagle schools can proudly boast of that annual event, as can many other communities. Here, a group of elementary-aged children pose for their class photograph on the grounds of Pleasant View School during the 1945–1946 school year. (Courtesy Phil Fry.)

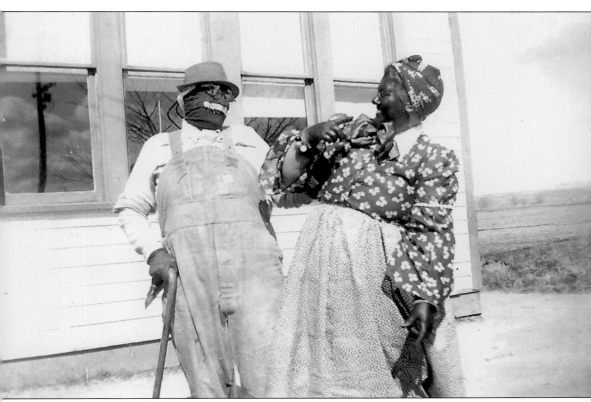

Blackface is a theatrical style that reached its peak of popularity in the mid-1800s. The beginning of the civil rights movement in the 1950s raised awareness of blackface's effects on racial stereotypes and prompted its fall from prominence on the American stage. Above, the year is 1942, and a blackface show is being put on for community entertainment at Pleasant View School. (Courtesy Phil Fry.)

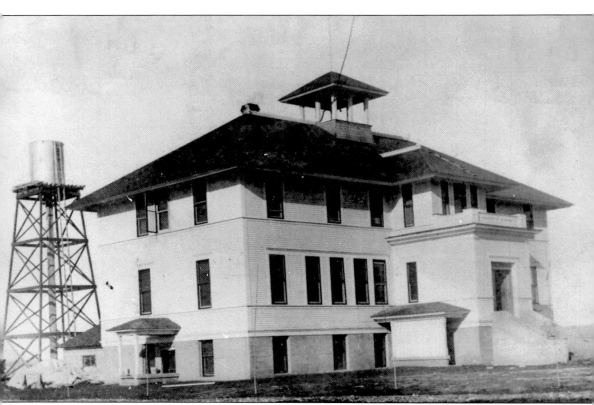

In the fall of 1907, Mrs. D.J. Bingman and her four daughters climbed into their buggy for a trip to church services in Boise just as they often did. It was a 12-mile ride, but the Bingmans were happy they could attend services with others of their faith. After the service, Elder Saxby asked Mrs. Bingman and John Heffner, also of Eagle, "Why not organize a church out at Eagle?" In July of the following year, a tent was pitched on the site of where the new Adventist Academy would stand so that those attending might organize a new church. The Adventists planned a complete campus of several structures, combined with a church community of numerous small farms, but this vision was dashed when the new school building burnt to the ground in 1911. (Courtesy Myrna Ferguson.)

The Adventist church was unable to open their next elementary school until 1929, when they added classrooms to their second church at Ballantyne and Floating Feather Roads. This school was maintained without a break until the congregation again relocated in the early 1970s. At one time, there were as many as 33 pupils and three teachers. Since the church vacated the building, it has served as a day care center and is currently a private home. It was formally placed in the National Register of Historic Places on August 18, 1980. Below, students and teachers play a game on the front lawn of the Ballantyne site around 1964. (Both, courtesy Myrna Ferguson.)

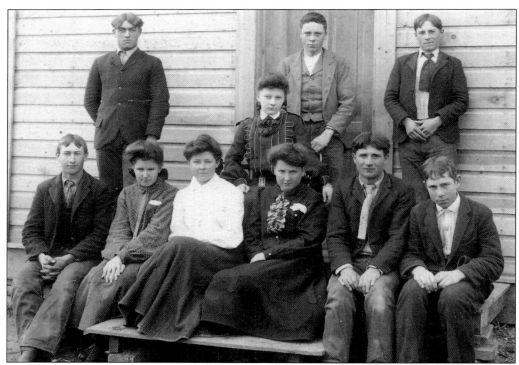

Eagle's earliest high school classes met from about 1904 to 1910 in the Odd Fellows Hall. These classes were financed by several local families who did not want their children traveling all the way to Caldwell or Boise to attend school. The families first hired a "college woman" to teach a freshman course only. When that proved successful, they hired another to teach the second year. In 1910, a new brick school was constructed on north Eagle Road. At this time, the high school classes were moved from the hall into the second floor of this new facility, Eagle Grade School. (Above, courtesy Weldon Fisher; below, Clare Walker.)

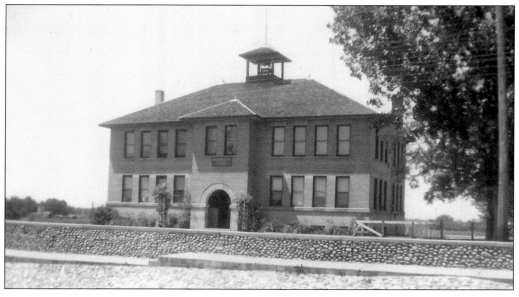

Even though a four-year course leading to graduation had been in place at Eagle High shortly after it moved to the top floor of the Eagle Grade School, graduating classes were often quite small. Here, Leonard Mace is flanked by only five other graduates in 1929. (Courtesy Jerry Mace.)

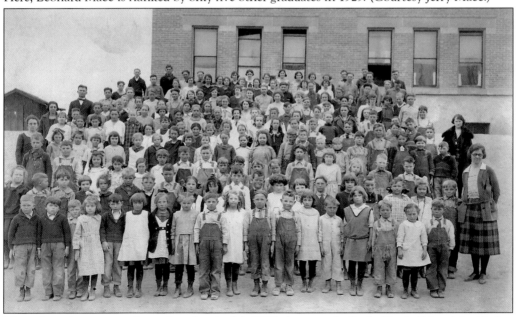

Most class pictures are of one class, but in this 1923 photograph, Eagle Grade School decided to feature the entire student body. As can be seen, the school population had considerably increased since the first one-room school was built and community high school classes began meeting in the Odd Fellows Hall. (Courtesy Edith Cohen.)

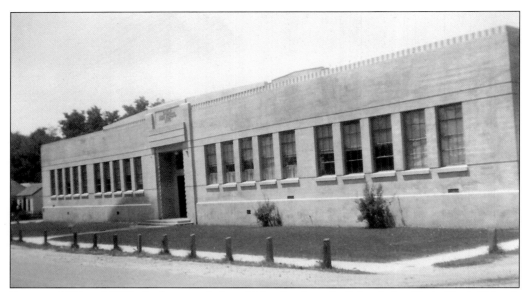

Between 1939 and 1940, the first stand-alone high school was built just below Eagle Grade School. This building served Eagle high school students until 1953, when Meridian School District No. 2, which Eagle is a part of, began bussing Eagle's high school students to Meridian High. This school then became a junior high. (Courtesy Clare Walker.)

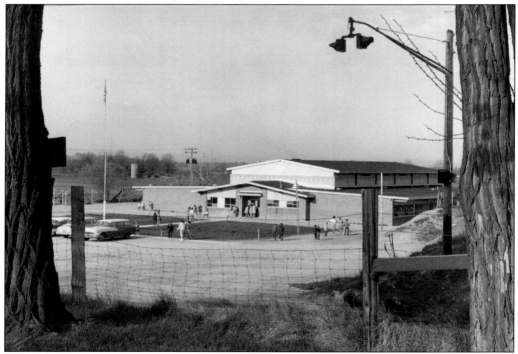

Once the old Eagle High School became a junior high, it served as such until 1959. At that time, it was torn down to make room for a parking lot and a school bus stop designed to accompany the newly completed Eagle Elementary School. Today, this school is known as Eagle Elementary School of the Arts. (Courtesy Les Cullen.)

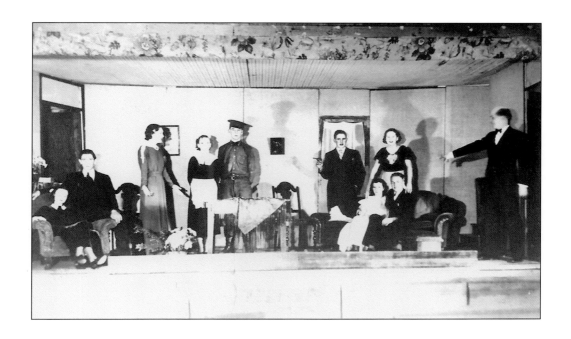

In the 1930s and 1940s, Eagle High School actively promoted a strong cultural arts program. For example, not one but five different plays were presented over the course of the 1936 school year. The same year saw the revival of school paper *Eagle Hi-Lites*, which had last been published in 1925. In 1940, Marvin Baker was hired as a music teacher, and under his tutelage, the school developed an excellent orchestra and glee club. Above is a scene from *Here Comes Charlie*, the first play of the 1936–1937 school year, and below is the 1939 high school orchestra. (Above, courtesy Bessie Hall Marshall; below, City of Eagle.)

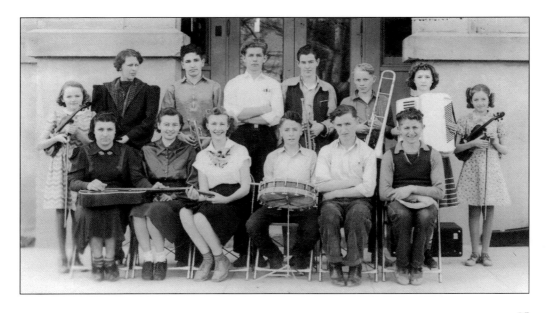

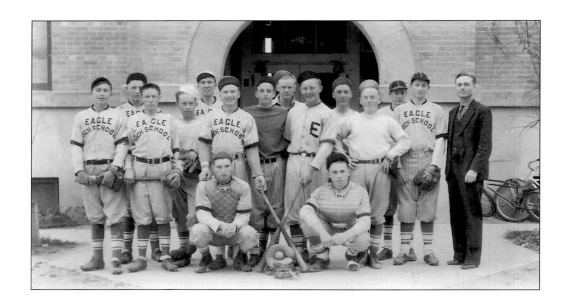

Sports were an essential part of high school life from the beginning. And although football and basketball were popular, baseball was always the standout. Affectionately known as "America's sport," baseball is actually a variation of the English games of cricket and rounders. By 1931, Eagle High School could already claim a respectable record for boys' baseball, and girls' baseball had been a reality for three years. Other teams fared well also. Above, coach Adrian Pollard poses with the 1937 boys' baseball team, and below, he kneels in front of the 1939 girls' basketball team. (Above, courtesy Bessie Hall Marshall; below, City of Eagle.)

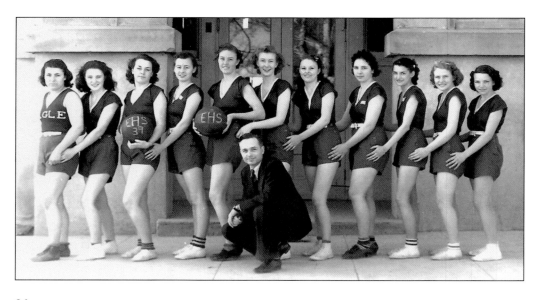

The Methodists and Baptists were the first to organize churches in the Eagle area. The Eagle United Methodist Church actually began in 1887 as the Boise Valley Methodist Episcopal Church. Originally located on Hill Road, it was dedicated on January 10, 1889. It was later sold, and a new church was built on Eagle Road in 1906. This photograph is of the second sanctuary. (Courtesy EHM.)

The First Baptist Church of Eagle originally met at a one-room schoolhouse in 1889. By 1895, the congregation had grown so large that a new building was erected. As Eagle grew, it was decided to move the church into town, and in 1906, the building was moved to land provided by Thomas Aiken, Eagle's founder. (Courtesy EHM.)

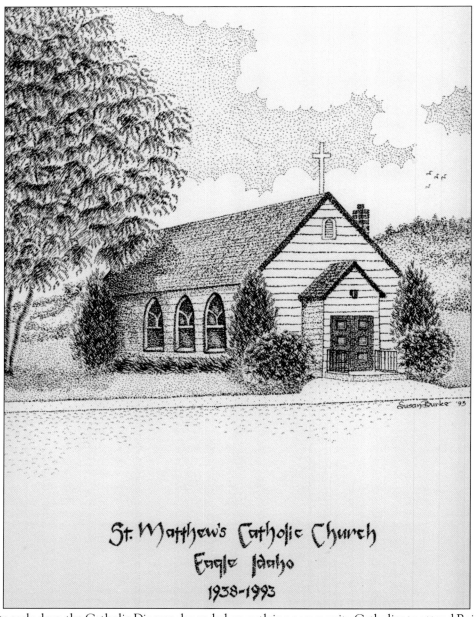

In its early days, the Catholic Diocese depended on outlying community Catholics to attend Boise's cathedral church, St. John's, whenever possible. In 1920, Rev. Daniel Gourman, then bishop of Boise, bought a piece of residential property in Eagle. The home was used as an auxiliary chapel for Eagle residents and became St. Mary's Catholic Mission. Seven years later, a small church designed by Tourtellotte and Hummel was built and dedicated on the west side of Eagle Road. In 1971, Eagle's Catholics purchased 10 nearby acres, subdivided the land into 10 home lots, and moved the small church onto land not devoted to homesites. At this time, the mission was changed to a parish church and renamed St. Matthew's Catholic Church. There are no extant photographs of that small parish, but this line drawing by Susan Burke nicely depicts how it looked. (Courtesy Judy Mendiola.)

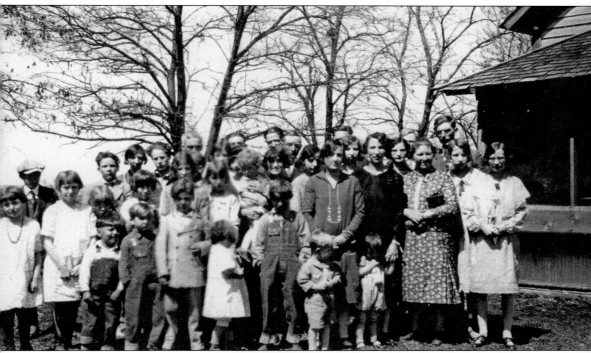

The Church of Jesus Christ of the Latter-day Saints first came to Eagle via the William Harris and Lorenzo "Ren" Marshall families who moved to Eagle in 1919 and 1920. Because they had no cars and were unable to attend church services in Boise, the home missionaries started a Sunday school in the Harris home in 1922. In the fall, the Sunday school started meeting in the Ren Marshall home and continued doing so for the next 13 years. The first local primary school was established in the Eagle home of Arthur Fuller in May 1947. After meeting at this location throughout the summer, the primary moved to the old Linder School. A year later, an Eagle Branch was organized by the president of the Boise Stake. In 1949, the congregants purchased the Pleasant View School building and converted it into a church. In 1962, they moved into their first new sanctuary on West State Street. Here, dedicated congregants gather in front of Ren Marshall's home in 1928. (Courtesy Ron Marshall.)

On September 30, 1923, eleven charter members of the Church of the Nazarene organized a congregation that met in the old Linder schoolhouse. In November 1924, they bought a corner lot at State and Second Streets and built a small wood-framed church that they used until 1952. Today, the Nazarenes worship in a church complex built in 1982. (Courtesy EHM.)

Samuel Slater began the first American Sunday school system in his textile mills in Pawtucket, Rhode Island, in the 1790s. Historically, Sunday schools were held in the afternoons and staffed by workers from varying denominations. In the early 1930s, the transition was made to Sunday mornings. Pictured here is a First Baptist Church Sunday school class from 1932. (Courtesy EHM.)

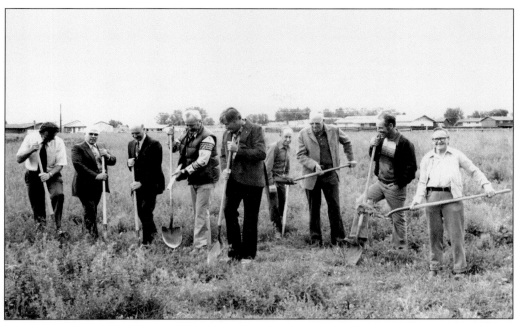

Members of the Eagle Adventist Church conducted ground-breaking rites on January 11, 1972, to start construction of a new church. The Eagle congregation had been meeting in a church erected at Ballantyne and Floating Feather Roads for 60 years but felt it was time to expand and move closer to downtown Eagle. Among those taking part in the ceremony were J. Marvin Adams (mayor of Eagle), L. Curtis Miller (pastor of the Eagle and Nampa Seventh-day Adventist churches), and Herman Andregg (head elder of the Eagle church). Construction of the new sanctuary came with an estimated price tag of $120,000, and the building was designed to seat 300. Eagle's Adventists still meet in this facility. (Both, courtesy Myrna Ferguson.)

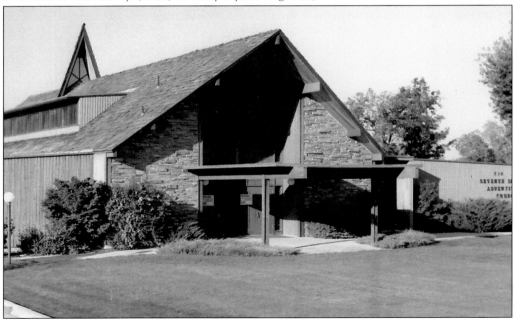

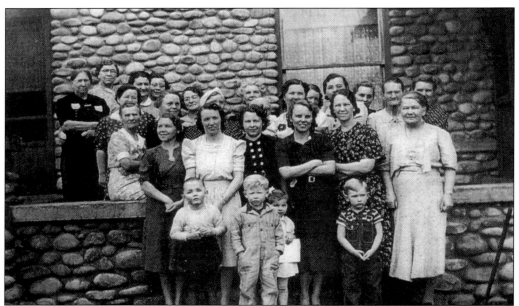

Above are members of the Dorcas Society, an Adventist society composed of people who provide clothing and linens to the poor. They are on the front steps of the Cobblestone House, the home built by prune magnate Oliver Francis Short in 1906. It was crafted entirely of cobblestones taken from the nearby Boise River and is one of six current National Register of Historic Places sites in Eagle. At the time this photograph was taken, the home was owned by Leonard Mace, a stalwart of the Eagle Adventist Church. Demonstrating her commitment to a totally different type of community involvement, Fran Venable staffs the Seventh-day Adventist display at the Western Idaho State Fair in the c. 1970 image below. (Both, courtesy Myrna Ferguson.)

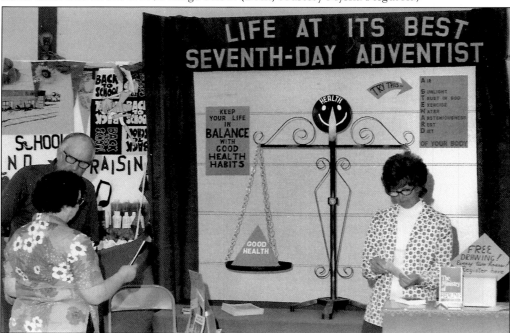

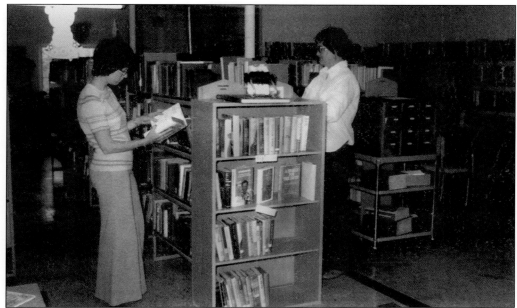

The Eagle Public Library has been serving the public since 1963, when it was first established as a volunteer operation by Ruth and Norvall Ostroot. Initially without a permanent home, the library moved in 1969 to 67 East State Street, where it remained for 30 years. From then until 1974, it continued as a volunteer operation, relying on moneys from community fundraising activities to keep its doors open. In May 1974, the library board petitioned and received permission from the Ada County Commissioners to turn over the library's assets to the City of Eagle in exchange for the city assuming financial support of the operation. Above, patrons search for a good read, and below, Janice Campbell leads a story time. (Above, courtesy City of Eagle; below, Janice Campbell.)

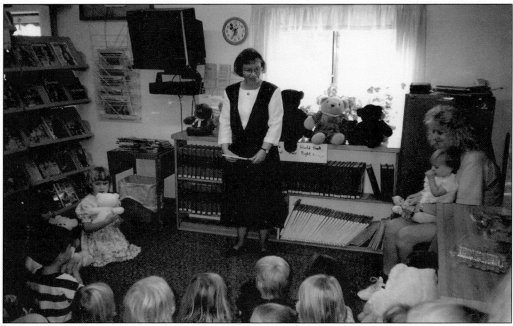

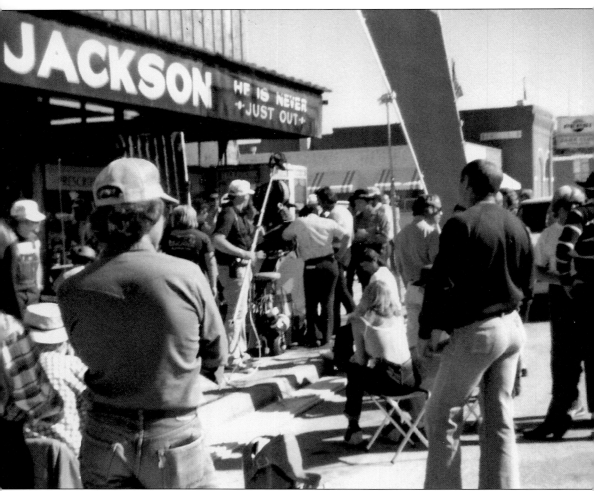

During the autumn of 1979, the Boise Valley played host to a movie crew as Clint Eastwood filmed a small feature called *Bronco Billy*. This 1980 Warner Bros. film is the story of "Bronco Billy's Wild West Show," a run-down traveling circus, the star of which is Bronco Billy McCoy, the "fastest gun in the west." The show is not making any money, and nobody has been paid for months. To make matters worse, Bronco Billy has taken a shine to and hired down-on-her-luck socialite Antoinette Lily, who is pressed into service at the wrong end of his knife-throwing finale. This casual snapshot was taken while the actors and crew were preparing to film a scene in which Antoinette Lily, while walking in front of the Eagle Drug Store, stops to read a newspaper headline and discovers that she is "presumed dead." (Courtesy EHM.)

Seven

Business in Orville Jackson's Tall Shadow

Orville Jackson and his famous Eagle Drug Store were at the heart of the Eagle business community for much of the 20th century. From 1922, when this young Idahoan bought his drugstore on State Street, until he retired in 1974, Jackson and his wife, Floy, made Eagle a destination for the surrounding community and for the rest of the valley. With friendly customer service, clever merchandising and marketing, and reputation for hard work and generosity, the Jacksons made their drugstore something more—a general store serving the needs of rural households with working farms, a gathering place with a soda fountain and the rare telephone, and a spot for advice and help when needed services were otherwise missing. The Jackson business model worked so well that another couple—Wayne and Jane Crosby—bought the store in 1974 and ran it successfully into the first years of the 21st century.

Jackson is remembered most by old-timers for helping get Eagle through the worst years of the Great Depression. When the Bank of Eagle closed in August 1932, Jackson's store became the de facto bank in the town. Jackson cashed workers' paychecks and farmers' creamery checks, often the only source of hard money for strapped farm families. He also extended credit; Jackson never refused to fill a prescription because the customer could not pay. In a Depression-era town without a doctor or a dentist, Jackson was also the only source of medical advice and help; he even pulled an occasional tooth. However, Jackson's most resourceful undertaking during the 1930s was the English Tudor house and gardens he built to give local men work—sort of his own private Works Progress Administration (WPA) project. This house is arguably still the most elegant structure in Eagle.

Jackson's store anchored a fairly stable and diversified downtown prior to incorporation. Such places as the Valley Market and the Eagle Merc also enjoyed relatively long histories. Despite noticeable gaps in services, there was also a surprising array of businesses in Eagle, including a funeral parlor and a haberdashery.

Orville Jackson was born in 1893 in the now nonexistent town of Salubria, Idaho. His parents moved to Council while he was still a tyke and then settled on a farm east of Cloverdale School situated near Meridian. During his teens, he lived on a ranch between Star and Middleton and graduated from Caldwell High School in 1913. Orville served in the US Army during World War I, and upon his return, he attended the College of Pharmacy at Drake University, Des Moines, Iowa. After passing pharmacy exams in both Iowa and Idaho, he worked at Ballou-Latimer's in Boise and then as a manager for a Star drugstore before purchasing the Eagle Drug Store on August 16, 1922, his 29th birthday. He was so beloved that on his 83rd birthday, an entire day was set aside by the City of Eagle to celebrate his many contributions to the community. (Courtesy Wayne and Jane Crosby.)

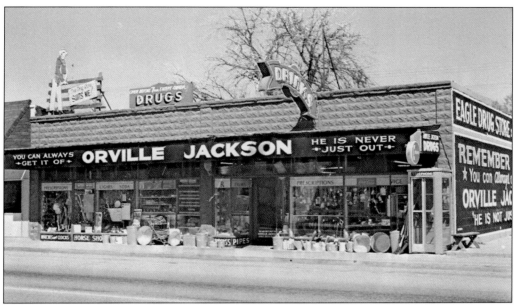

The Eagle Drug Store, or "Orville Jackson's," as it was also referred to as, became known throughout the Boise Valley as the store that had everything. Over the years, Orville and his wife, Floy, worked together to create the reputation the store enjoyed. Jackson always wanted to meet the needs of his customers, so his slogan was "you can always get it of Orville Jackson, he is never 'just out.'" To honor his slogan, his inventory included products as diverse as animal vaccines, mule and horse shoes, ammunition, cast-iron cookware, leather goods, and tobacco, just to name a few. Above is a sampling of what Jackson had to offer, and below, he poses with Floy in front of their joint venture. (Above, courtesy Wayne and Jane Crosby; below, Shari Sharp.)

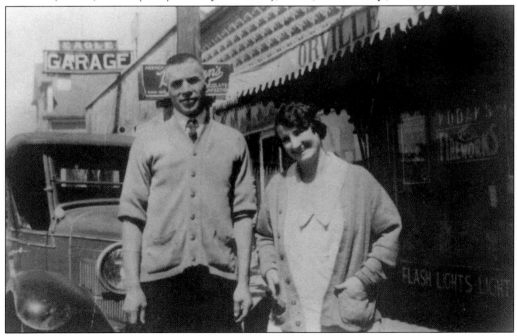

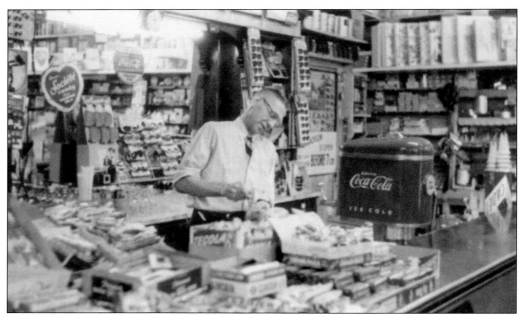

Whenever Jackson heard the front-door sleigh bells at the store ring, he would respond with, "Howdy, neighbor." His desire to provide top-flight service apparently knew no bounds. Locals remember the store as a friendly place where they could get whatever items they needed. In his 52 years of service, Jackson never once refused to fill a prescription because his customer could not pay for it. He also made a habit of sending new parents baby books and using charge accounts before it was common practice. Above is a late-1950s image of Jackson working behind the soda fountain, and below, he and Floy jointly celebrate his 79th birthday and 50 years of ownership. (Both, courtesy Shari Sharp.)

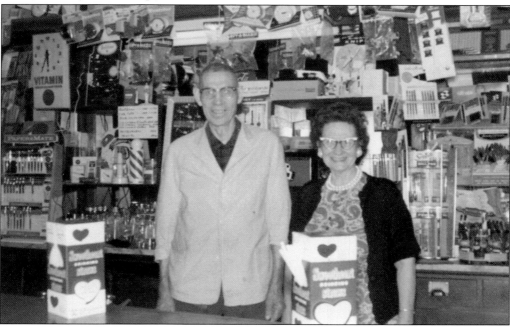

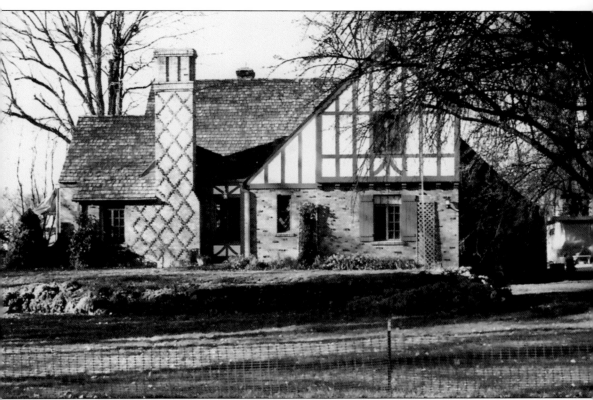

This lovely 1930s Tudor-style home was designed by Tourtellotte and Hummel, then the best-known architectural firm in southwest Idaho. The firm generally specialized in works of a more sedate nature but was apparently persuaded by Orville and Floy Jackson, who commissioned the home, to take on the challenge of this more picturesque residence. They might also have been persuaded by the fact that the Depression was noticeably cutting into their workload and so decided to branch out a bit. Add to its inherent charm the sunken garden landscaping of Meridian nurseryman David Petrie, and it is easy to see why this home was and is considered one of the finest examples of this architectural genre in the state. It was added to the National Register of Historic Places on November 17, 1982, and is recorded as a significant example of Tourtellotte and Hummel's work. (Courtesy EHM.)

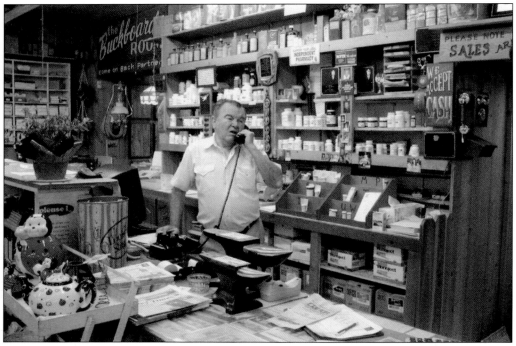

In May 1974, Orville sold his business to Wayne and Jane Crosby. Though no one realized it when they first took over, the Crosbys were the perfect successors to the Jacksons. Over the years, they made some site improvements but also maintained the legacy their predecessor had left to them. The store continued to maintain a stock that could satisfy even the most demanding customer, and their commitment to top-flight service never wavered. In the image above, Wayne helps a phone client, and below, Jane (left) and longtime clerk Sue Graham smile for the camera. (Above, courtesy Wayne and Jane Crosby; below, EHM.)

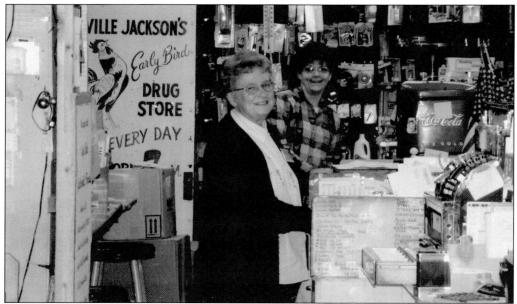

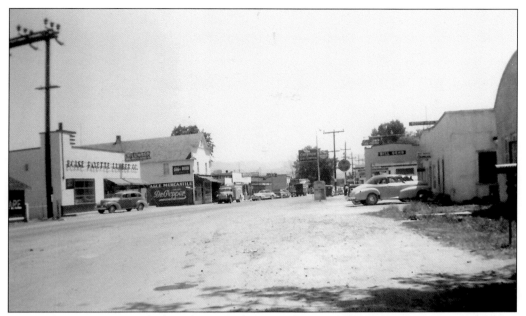

The Eagle Drug Store might have been the business that initially attracted people to Eagle, but once here, they could avail themselves of numerous other businesses and services. Looking east down State Street in 1949, one can easily spot the Boise Payette Lumber Co., Eagle Mercantile, and the Chevron Gas Station. (Courtesy Clare Walker.)

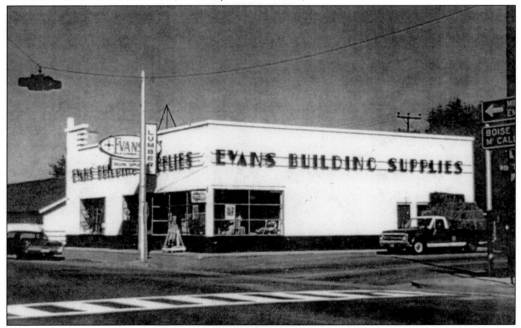

Evans Building Supplies, originally named the Boise Payette Lumber Company, was purchased by the Cliff Evans Corporation in 1964. After major improvements and modernization, this new Eagle store held its grand opening in June 1967. The business remained at this site until January 1981, when it relocated farther to the west on State Street. (Courtesy EHM.)

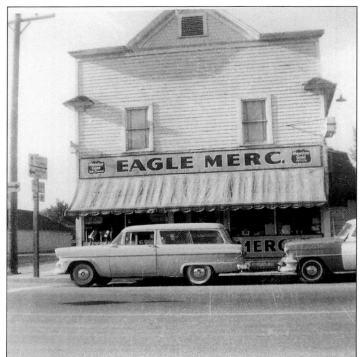

In 1902, John Carpenter deeded the corner of land reaching from Highway 69 east to where Orville Jackson's store stands to IOOF Valley Lodge No. 100. The lodge members then constructed their hall on this site, and for many of its 62 years, it housed the Eagle Mercantile. (Courtesy Tim Soran.)

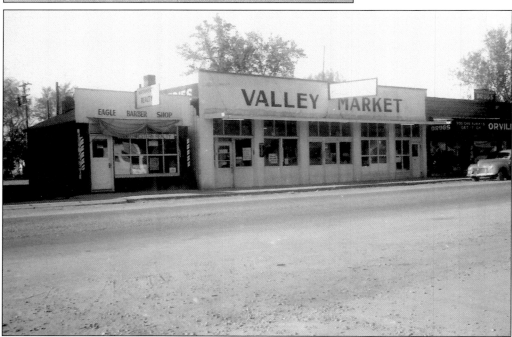

The Valley Market, also featured on the cover, was next to the Eagle Drug Store. In this slightly later view, the Eagle Barber Shop has taken over what used to be a vacant lot. Sometime between then and the 1970s, the barbershop moved from its spot next to the market across the street to an equally snug spot beside the Eagle Public Library. (Courtesy Tim Soran.)

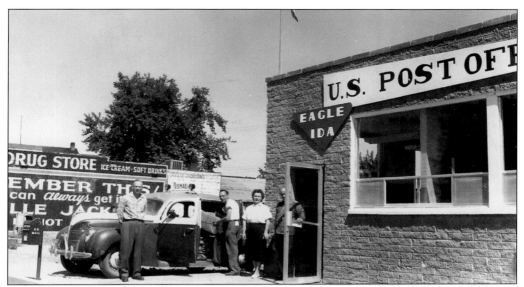

Eagle's first stand-alone post office was dedicated in June 1959. The new post office contained 350 locked boxes and supported two rural routes: Eagle Route No. 1 and the Pearl Star Route. From left to right are postmaster Delbert Taylor, Eagle Route No. 1 driver Norval Ostroot, clerk Helen House, and an unidentified man. (Courtesy EHM.)

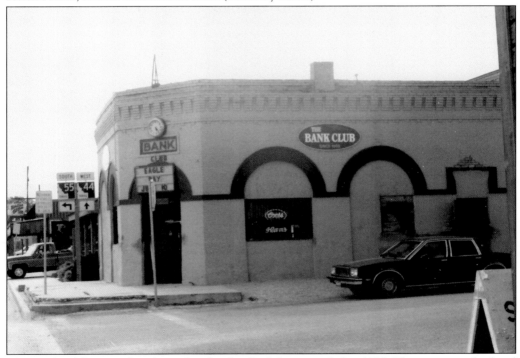

The Bank Club opened its doors shortly after Prohibition ended in 1933. The most popular local watering hole for many decades, it became known throughout the Eagle area for its lunches and dinners. In the late 1990s, the building enjoyed a face-lift and reopened as the Italian restaurant Da Vinci's. (Courtesy City of Eagle.)

Mountaineer Meat Company was owned by Eagle's first elected mayor, Marvin Adams. He erected the building in 1947 as Adam's Frozen Food Locker, where he butchered and sold meat, rented cold storage lockers, and made and sold ice cream. He then leased the building to Boise Valley Packing Co. (Courtesy Patricia Hicks.)

Many Eagle eating establishments have come and gone over the decades. Loop's Café, which set up shop directly across from Orville Jackson's during the 1950s, was one of the more short lived, perhaps because it was unable to compete with the drugstore's famous soda fountain. (Courtesy Tim Soran.)

In 1958, Cloyce and Helen Plecker sold their small farm, and Helen, who had worked for a number of years at various coffee shops, decided to try her hand at running a small café. With the aid of a real estate agent, she and Cloyce quickly found the available Eagle Grill and purchased it from Leo Soran, pictured at right, in October 1958. Tim Soran, Leo's son, speaks fondly of his formative years in Eagle and remembers that his father and the Pleckers had much in common: they both harbored a keen sense of place and the importance of cultivating a regular clientele through the twin services of good food and a warm welcome. (Courtesy Tim Soran.)

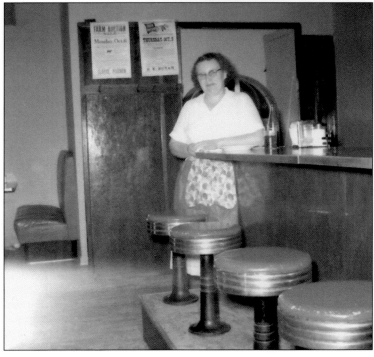

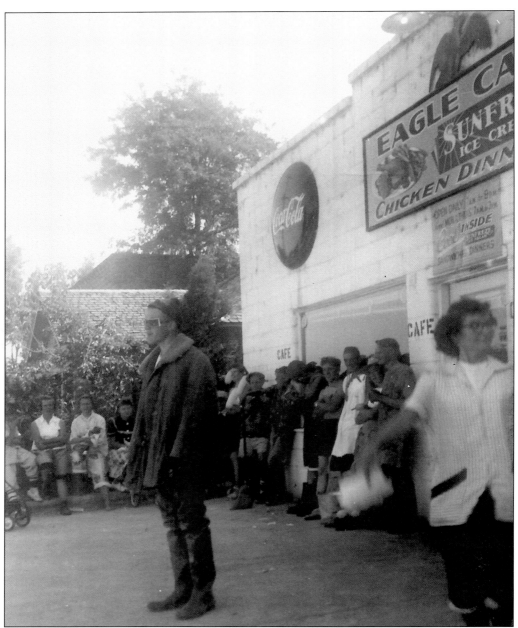

While being interviewed for an article in the *Valley Free Press* in October 1982, "Ma" Plecker, as she was known, noted that the early 1980s influx of out-of-state residents was already beginning to take its toll on the rural community she and her husband had served so faithfully for 24 years. Fortunately, for those who thought of the café as a community gathering place and a home away from home, the eatery remained essentially unchanged. Everyone who entered, both old-timer and newcomer, was welcomed with the same kind of service and good home cooking that had characterized the grill for years. As can be seen here, the formula worked when Leo Soran operated the café in the early 1950s and continues to work today in the café's latest incarnation as the Wild West Bakery & Espresso. (Courtesy Tim Soran.)

Because State Street was a main transportation artery between Boise and the valley, gas stations and car repair facilities quickly sprang up along its Eagle easements. In the 1930s, the Standard Oil Station fronted the Hitchcock Building at the corner of Eagle Road and State Street, and in the 1950s, Harry Purcell's Oil Co. and Conoco Service Station could be found doing a healthy business just to the east. Above, Delbert Taylor poses in front of the Standard Station, and pictured below is the Harry Purcell Oil Company and Eagle Conoco Service, which was located at the northwest corner of East State and Second Streets. (Both, courtesy EHM.)

Not all Eagle businesses maintained a storefront on State Street. Charles Dawson Crist, a man of multiple talents, moved to Eagle with his family around 1917. An electrician, farmer, mechanic, and barber, he bought a house and acreage on State Street just to the east of the Eagle Drug Store. The property was known as the Old Crist Home, and in 1998, a portion of it became the site of Heritage Park. Crist worked for Idaho Power and also at Glen's Ferry for the railroad. In addition, he had a small barbershop at the back of his home and a garage behind that. He installed the first substation for the dial telephone system in Eagle in the late 1940s and, shortly before retirement, leased a service station at the west end of town. Here, Crist sits in front of his home in July 1957. (Courtesy Larry Crist.)

Eight

IN PURSUIT OF LEISURE

Early Eagle shared the homely leisure time pursuits associated with country and small-town life with much of rural America, such as homemade music, picnics, camping trips, church socials, school athletics and drama, lodge events, family reunions, and county and state fairs. Where Eagle differed from most other rural settlements was in its interurban trolley and the access this gave to the entertainments and diversions of Idaho's capital and largest city, conveniently located only 12 miles away. Day tripping on the trolley to Boise became possible in August 1907, as well as to Nampa and Caldwell soon thereafter. In short, Eagle became suburban very early in its history; however, a demanding, hardscrabble farm life limited the amount of leisure and money available to Eagle-area residents during the first half of the 20th century and tended to foster the enjoyment of rural, local pursuits well into the era of the automobile.

After incorporation, Eagle's civic and business leaders found it useful to maintain the illusion of small-town life as part of the city's marketing strategy. Various public events throughout the year hearken back to Eagle's simpler, rural heritage. The city's premier civic celebration, Eagle Fun Days, is now staged annually on the second weekend of June as a multi-event extravaganza coordinated by the Eagle Chamber of Commerce. It has shallow historical roots, though. No elements of Fun Days can be traced back beyond the 1950s, anything before that usually involved fundraising by the Eagle Volunteer Firemen's Association. In 1964, a parade down State Street was added to what was then called the Fun Fair.

The first official Eagle Fun Days was not staged until 1976, and it was tied in to the nation's bicentennial celebration. Surprisingly, Fun Days has often had a raucous edge to it. Too much beer, summer heat, and too many people packed into Eagle's small downtown area led to violence as late as 1997. Since then, organizers have spread out the venues and emphasized the family-friendly nature of events. Still, many Eagle residents tend to leave for cabins or vacation homes during the crowded Fun Days weekend.

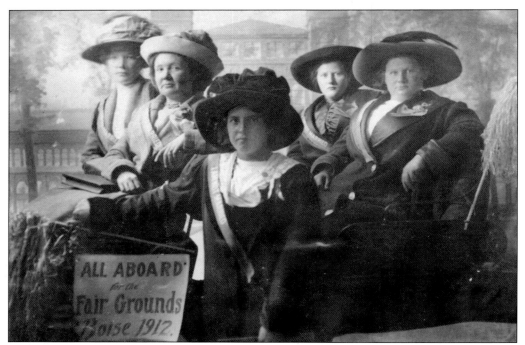

In the early 20th century, state fairs often provided an opportunity for fairgoers to have their picture taken with a tableau backdrop and various props. These images were midway between truly staged studio portraits and the modern-day photo booth. Here, Blanche Fisher (center front) and a few friends pose at the Boise Fairgrounds in 1912. (Courtesy Les Cullen.)

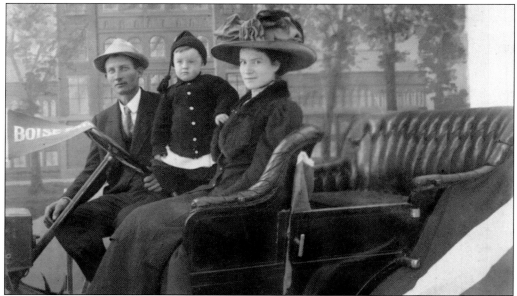

When the Otto Fry family posed for this Boise State Fair photograph, the background remained the same as in the previous image, but the car and sign had changed. It is difficult to determine if this image was taken prior to or later than the one above, but there is little doubt that the photographer's tableau had not changed much. (Courtesy Phil Fry.)

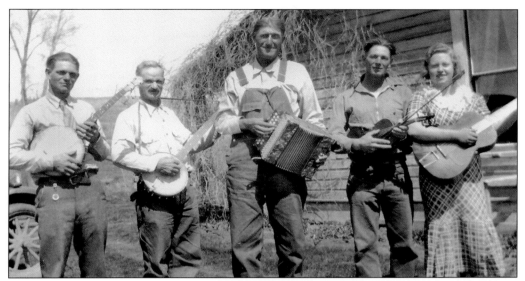

Living off the land is a hard way to make a living, and people often have hobbies to distract them from their daily work and concerns. Above is a group of talented Eagle Island musicians who obviously enjoyed their craft. Pictured from left to right are Walter "Boots" Robinson, Lavern Robinson, Otto Hansen, Earl Robinson, and Lola Rogers. It is Easter Sunday 1936, and they have banded together for an impromptu concert. George W. Fry (fifth from left below), an early Eagle homesteader, enjoyed music as well. Here, he plays with the Idaho Fife and Drum Band of the Grand Army of the Republic at Long Beach, California, in 1918. (Above, courtesy Ann Rogers; below, Phil Fry.)

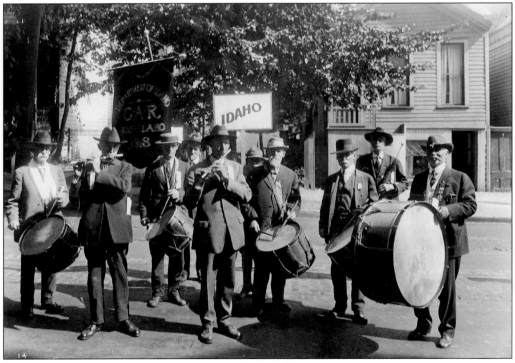

Sometimes the best kind of leisure is simply that quiet moment that people find for themselves amid the ongoing responsibilities of daily life. Here, Ella Fisher, matriarch of the pioneering Fisher clan, enjoys a moment of solitude in the garden at her home on State Street. (Courtesy Edith Cohen.)

Picnics, originally seen as events where everyone brought a dish to a common feast and not the casual outdoor meal enjoyed today, were a popular pastime for many early settlers. Here, five of the younger Fisher children enjoy a picnic outing with their older sister Lulu (fourth from left) and her husband, Jim Gilbert. (Courtesy Edith Cohen.)

The old proverb, "A woman's work is never done," can occasionally be disputed. Here, Bessie (Baker) Fry sits outside her home taking advantage of the few moments of leisure that her new Overland automobile-powered washing machine is providing her. She is enjoying an issue of *Woman's Home Companion*, a popular American monthly published between 1873 and 1957. The c. 1916 image was captured by Otto Fry, her husband. Below, Raymond Frasier of the Frasier family of Eagle Island sits back and enjoys his harmonica while the family washing machine takes care of the wash itself. (Above, courtesy Phil Fry; below, Marvin Frasier.)

Earl Fisher, the youngest child of Eagle pioneers George and Ella Fisher, was said to have owned only four cars during his lifetime. Apparently, his love for the premier form of 20th-century transportation started early on. Here, he is seen taking a spin in what could be considered his first automobile. (Courtesy Edith Cohen.)

When he became a bit older, Earl purchased a Ford Model T, the first car he did not have to propel himself. Apparently, it was to be the first of three, and it was his transition from old-time horsepower to motorized horsepower. According to his daughter, he only owned two other automobiles, and she remembers his 1928 and 1949 Chevrolets well. (Courtesy Edith Cohen.)

Prior to private ownership of an automobile, travel to a vacation spot could be both time consuming and rugged. In July 1913, Charlie, Mary, and their young son Leonard Mace took a covered wagon to vacation at Yellowstone and probably thought little of it. Just two years later, the Otto and George W. Fry families, who could afford a car because of the high crop prices of World War I, also took advantage of the chance to get away. Here, both families enjoy a hard-earned rest along the Payette River in Garden Valley. (Above, courtesy Jerry Mace; below, Phil Fry.)

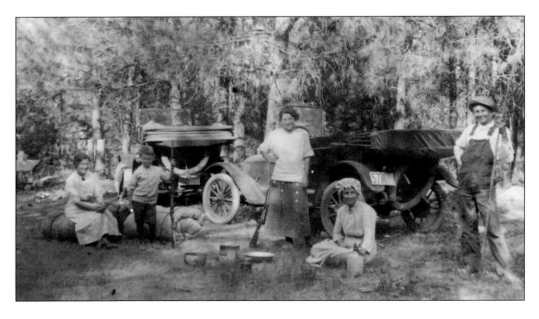

Of the original 15 Fisher children, 12 were still living in the early 1950s when this family reunion photograph was taken. Pictured from left to right are (first row, seated) Emma Swan, Lulu Gilbert, Maud Stillwell, Blanche Cullen, Ina Greiner, and Lena Hall; (second row, standing) Orien, William, Theo, George, Bryan, and Earl. This particular event was held at Bill and Clara Fisher's home. Reunions for graduates of old Eagle High School, closed in 1953, are also a popular event enjoyed by the community. Below is a group photograph at the 2007 reunion. (Above, courtesy Edith Cohen; below, Ron Marshall.)

Little League baseball teams have been around for a long time, and almost all small communities can boast of at least one team. Eagle has apparently had several teams over the years, one being the Eagle All Stars, shown here with coach Leo Soran, then owner of the Eagle Grill, around 1959. (Courtesy Tim Soran.)

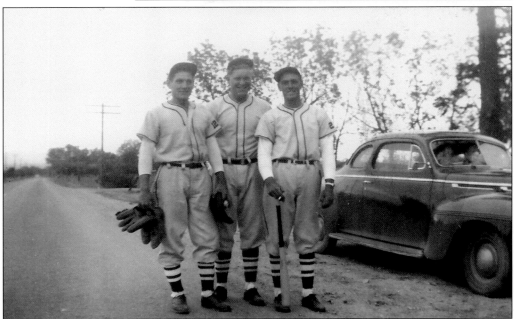

Older boys can be as enamored of baseball as some younger boys. In the 1920s, the American Legion formed a baseball program for teenage boys that still exists today. American schools also started baseball programs about the same time. These three members of the Eagletown baseball team—from left to right, Fred Kunkler, Don House, and Marv Reutzel—proudly pose in their uniforms. (Courtesy Lois Kunkler.)

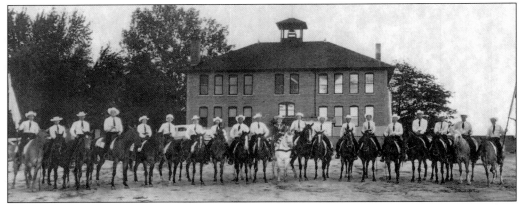

The Eagle Riding Club was named the top riding club of 1958 at the Snake River Stampede, a Nampa-based rodeo that traced its humble beginnings to a bucking contest held in conjunction with Nampa's harvest festival. Here, the club poses behind Eagle Grade School. (Courtesy EHM.)

Mr. and Mrs. Theodore Fisher, pictured here in 1964 with Robert Weybright, United Airlines supervisor of passenger service, are preparing to take off from the Boise Municipal Airport for a Florida vacation. Fisher, 80 years old, was taking his first plane ride, which, notably, would follow much the same route that his family had taken when they came by wagon to Idaho from Iowa in 1889. (Courtesy EHM.)

Eagle's largest and most popular civic event is its annual Eagle Fun Days celebration. This activity can trace its roots to August 2, 1964, when the first Eagle Fun Fair began with a parade, followed by daylong events and an auction at the Eagle Grade School. Sponsored by the Eagle Community Improvement Committee, the fair's goal was to improve the baseball field at the school. New bleachers were finished and installed before the fair, and construction engineer Joey Cullen said work would begin on a new backdrop shortly thereafter. Pictured above, volunteer Reba Cullen and Eagle Grade School principal Damon Flack examine the site designated for the bleachers, and below are the volunteers who helped construct them. (Both, courtesy Les Cullen.)

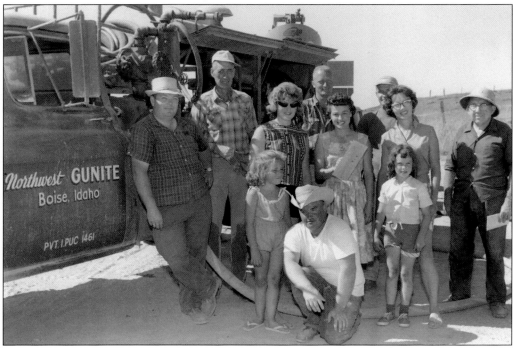

The original Fun Fair was successful because of the number of volunteers involved in its mounting and that it was able to achieve its fundraising goals. Among its numerous promoters was Jim Dunn, a local parking meter representative. He arranged for the donation of a single meter that was fitted with a special sign labeled "Mayor's Emergency Fund," which was then used to publicize the fair's fundraising efforts. The meter was placed in front of the old library building, and honorary mayor and radio personality Bob Salter unveiled it during the Fun Fair festivities. Today, it resides in the entryway of the Eagle Historical Museum, a little worse for wear from its longtime exposure to the elements; however, it is still a proud symbol of Eagle's community's fundraising activities and the fact that the city has never charged for parking. (Courtesy EHM.)

The earliest parades trace their origins to military spectacle. Later on, parades became associated with fairs and festivals. As with other forms of entertainment, the public anticipated such events, and parades were viewed as a means of providing respite, however fleeting, from the toil and drudgery of everyday life. Whether large and flashy like the Mardi Gras and the Tournament of Roses parade or a small-town affair like Eagle's Fun Days parade, these events all share certain elements. After all, is there a parade that does not at some point feature antique cars and horses? (Courtesy Vicki Nielson.)

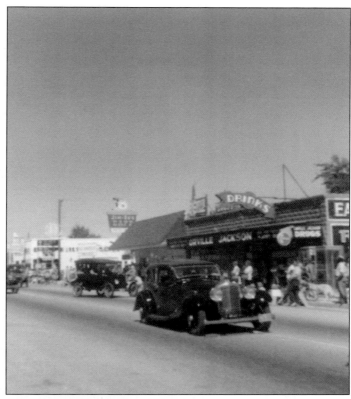

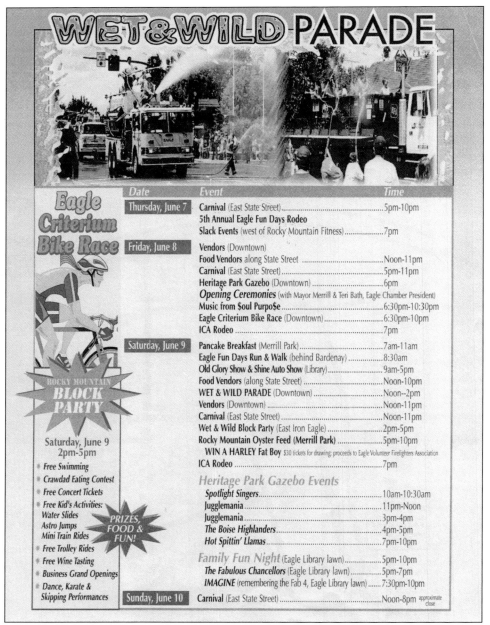

Local residents marched in Fun Days parades from the very beginning, and as the years passed, other elements were added to not only the parade but to all other aspects of Fun Days. During the original Fun Fair, the Eagle Fire District staged both a fireworks display and engaged in a water fight with firemen from Kuna. To this day, the annual water fight between the firemen, other parade participants, and the folks on the sidelines is a highlight of the Fun Days festival. As can be seen from this 2007 flier, other elements that are commonplace today were not a part of the original celebration. The Fun Days Rodeo, various bike races and sporting events, and Heritage Park Gazebo events have all been added over the years to meet the expectations of this ever-expanding community. (Courtesy EHM.)

Rocky Mountain oysters are a well-known novelty dish. Allegedly cowboy fare, they are commonly served at festivals, among ranching families, or at certain specialty bars or restaurants. Eagle's very own "World's Largest Rocky Mountain Oyster Feed" falls into the festival category. Of long-standing tradition, the "Nut Feed" started in the 1950s as a small gathering and now hosts several thousand people a year. Proceeds go to support the Eagle Volunteer Firefighters Association, which works to provide a pool of volunteers to assist the Eagle Fire Department. Featured above is a long line of anticipatory diners, and below is an advertisement for the 1988 feed. (Both, courtesy Eagle Fire Department.)

The 2002 Winter Olympics were held in Salt Lake City, Utah. The torch relay preceding these games was a 65-day run beginning on December 4, 2001. Runners carried the Olympic flame throughout the United States, following its lighting in Olympia, Greece, to the opening ceremony. Karie Arnold, pictured here with her parents, Fred and Lois Kunkler, was one of the local athletes who carried the torch while it passed through Boise. The 2009 Special Olympics World Winter Games were held in Idaho from February 7 through February 13 in 2009. Numerous events were held in Boise, and while there, some of the competitors visited Eagle. Below, Eagle firefighters pose with Special Olympics Netherlands Olympians. (Above, courtesy Lois Kunkler; below, Eagle Fire Department.)

Occasionally, there is no need to look any further than one's own heritage for a leisure-time activity. Eagle began its life as a rural farming community and essentially remained as such for the 80-some years that led into its late-20th-century boom. Through good times and bad, the majority of its citizens made their living off the land, and they were justifiably pleased with their heritage and production. Pictured above, Rick (left) and Fred Kunkler proudly show off the result of a fun labor of love: a completely restored McCormick Deering Farmall tractor that was used to work their land for many years. Here, the terms "labor" and "hard work" take on a totally new meaning; they become life-affirming and transcendent when viewed with the hindsight knowledge of a job well done. (Courtesy Lois Kunkler.)

BIBLIOGRAPHY

Baker, Ronald J. *A Brief History of Eagle, Idaho, Prepared for the Association of Idaho Cities*. Eagle, ID: Eagle Public Library, 2005.

Casner, Nick, and Valerie Kiesig. *Trolley: Boise Valley's Electric Road, 1891–1928*. Boise, ID: Black Canyon Communications, 2002.

Davis, Belinda. *A Study of Irrigation and the Development of Ada County*. Boise, ID: Ada County Historical Preservation Council, 1990.

Eagle Island State Park Master Plan. Boise, ID: Beck & Baird, 2000.

Hart, Arthur A. *Life in Eagle, Idaho: The City's Past by the People Who Lived It*. Eagle, ID: Eagle Historic Preservation Commission, 2008.

Hawley, James H. *History of Idaho, the Gem of the Mountains*. Chicago: The S. J. Clarke Publishing Co., 1920.

Patterns of the Past: The Ada County Historic Site Inventory. Boise, ID: The Arrowrock Group., Inc., 2001.

Stacy, Susan M. *When the River Rises: Flood Control on the Boise River, 1943–1985*. Boise, ID: Boise State University, 1993.

About the Organization

The Eagle Historical Museum is located in downtown Eagle across from the old Orville Jackson drugstore. Though it is managed and maintained by the City of Eagle today, it represents the combined early efforts of the Eagle Historic Preservation Commission and the Eagle Historical Society to provide a home and interpretive framework for the many artifacts and documents that have been collected for years by history-conscious members of the community.

The museum opened its doors to the public in October 2001, and since then, it has been actively involved with community events and collecting materials that can be incorporated into its various exhibits and maintained in the museum archive. These archival collections are available to the public for research, as well as internal research, and to respond to the many questions posed by regular visitors.

Discover Thousands of Local History Books Featuring Millions of Vintage Images

Arcadia Publishing, the leading local history publisher in the United States, is committed to making history accessible and meaningful through publishing books that celebrate and preserve the heritage of America's people and places.

Find more books like this at
www.arcadiapublishing.com

Search for your hometown history, your old stomping grounds, and even your favorite sports team.

Consistent with our mission to preserve history on a local level, this book was printed in South Carolina on American-made paper and manufactured entirely in the United States. Products carrying the accredited Forest Stewardship Council (FSC) label are printed on 100 percent FSC-certified paper.